751·426

inting

a Dewberry

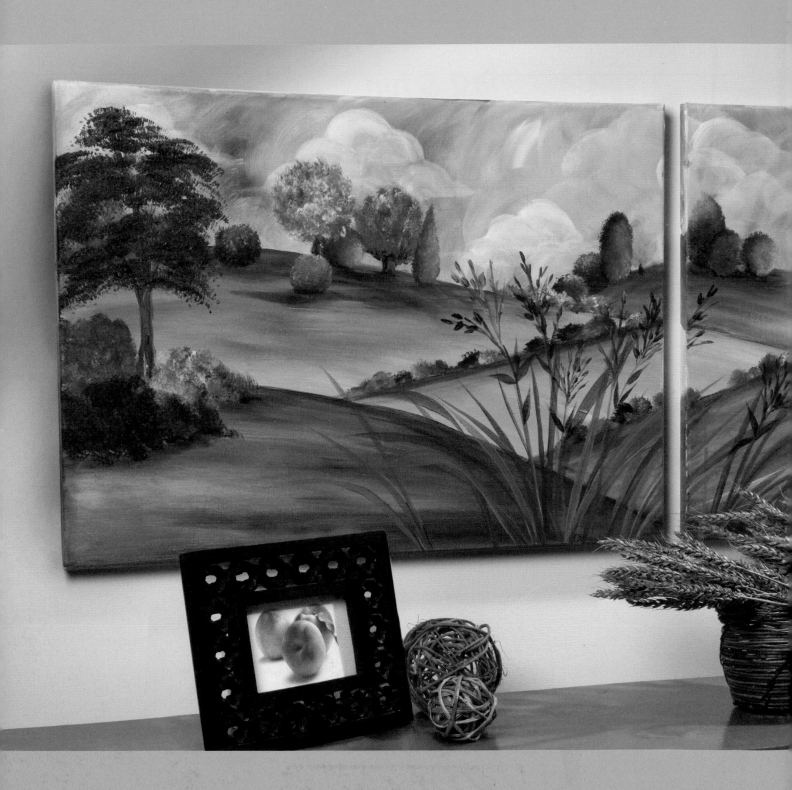

fast & fun landscape painting

WITH **Donna Dewberry**

NORTH LIGHT BOOKS

Cincinnati, OH
www.artistsnetwork.com

fw

F+W PUBLICATIONS, INC.
www.fwbookstore.com

Other fine North Light Books are available from your local bookstore, art supply store or direct from the publisher.

11 10 09 08 07 5 4 3 2 1

Distributed in Canada by Fraser Direct
100 Armstrong Avenue
Georgetown, ON, Canada L7G 5S4
Tel: (905) 877-4411

Distributed in the U.K. and Europe by David & Charles
Brunel House, Newton Abbot, Devon, TQ12 4PU, England
Tel: (+44) 1626 323200, Fax: (+44) 1626 323319
Email: postmaster@davidandcharles.co.uk

Distributed in Australia by Capricorn Link
P.O. Box 704, S. Windsor NSW, 2756 Australia
Tel: (02) 4577-3555

Library of Congress Cataloging-in-Publication Data

Dewberry, Donna S.
 Fast & fun landscape painting with Donna Dewberry / Donna Dewberry.
 p. cm
 Includes index.
 ISBN-13: 978-1-60061-025-7 (pbk. : alk. paper)
 1. Landscape painting--Technique. I. Title. II. Title: Fast and fun landscape painting with Donna Dewberry.
 ND1342.D494 2008
 751.4'26--dc22
 2007026707

Edited by Kathy Kipp
Design & Interior Layout by Clare Finney
Production coordinated by Greg Nock
Photographed by Christine Polomsky, Al Parrish, Greg Grosse

METRIC CONVERSION CHART

To convert	to	multiply by
Inches	Centimeters	2.54
Centimeters	Inches	0.4
Feet	Centimeters	30.5
Centimeters	Feet	0.03
Yards	Meters	0.9
Meters	Yards	1.1

ABOUT THE AUTHOR

Donna Dewberry is the most successful decorative painter ever. She is the originator of the One-Stroke painting technique, and has developed the One-Stroke Certified Instructor (OSCI) program for teachers. She is seen weekly on PBS stations nationwide with her program "The Donna Dewberry Show" and is also a regular presenter on the Home Shopping Network. Her designs are licensed for home décor fabrics, wallpapers, borders, bedding, needlework, and paper crafts. Donna has published ten books with North Light; her most recent is *Donna Dewberry's Painted Garden* (2007).

A NOTE TO MY PAINTING FRIENDS

Once upon a time in my long painting career I was challenged to step out of my comfort zone and try something new and completely different than what I was accustomed to. I learned new things that were hard to do at first, but I grew and soon new things felt natural. Well, again, another challenge has presented itself—I have discovered the world of landscape painting!

I have always had a passion for painting but viewed what I painted as more craft than art. When I began my journey into landscapes, I began to feel more like the traditional definition of an "artist." Sometimes the colors and designs still remind me of my decorative painting, but the perspective I can achieve seems much more artistic. The textures possible with the High Definition paints lends to the feeling of true oil painting. Now each time I approach my easel I find myself willing to paint something new and different. Even though I may not master it immediately I am comfortable in touching my brush or palette knife to the canvas and attempting to paint what I see.

Along the way I discovered that my approach to landscape painting could be simplified into three steps: 1. Place in the background; 2. Paint the focal point or center of interest; 3. Fill in with the details. Thinking about each new painting in this way helped me overcome that initial hesitation when facing a blank white canvas and helped me see the logical flow to each new design.

I dedicate this book to each of you who has ever desired to paint landscapes. I invite you to open up to the possibilities and allow your heart to follow a new path. Be glad for the challenges put before you, for they will truly help you grow.

ACKNOWLEDGMENTS

Each time I complete a book I take a moment to look back and remember all those who made it possible. This book was a new and exciting endeavor and as I reflect on those who helped made it a reality, I am humbled and thankful for their hard work and contribution.

Thanks to Kathy Kipp, my editor at North Light Books, and her team for their belief in me; to Maxine Harnish at Tara Materials for her generosity; to Jim from Plaid Enterprises for his vision of the HD paint; and to each and every one who has contributed to this book's creation and publication. You are each awesome and although I don't know everyone by name, my heart says "thank you." It truly takes a combined effort and real teamwork to create a book and I think my team is the best!

—Donna

Table of Contents

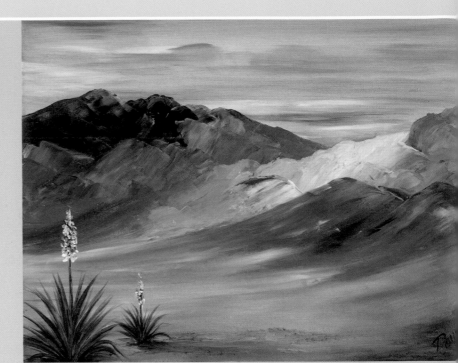

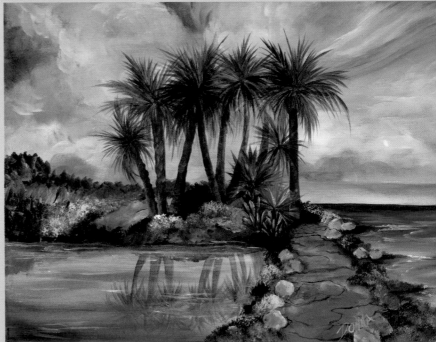

PAINTING LANDSCAPES THE ONE-STROKE WAY

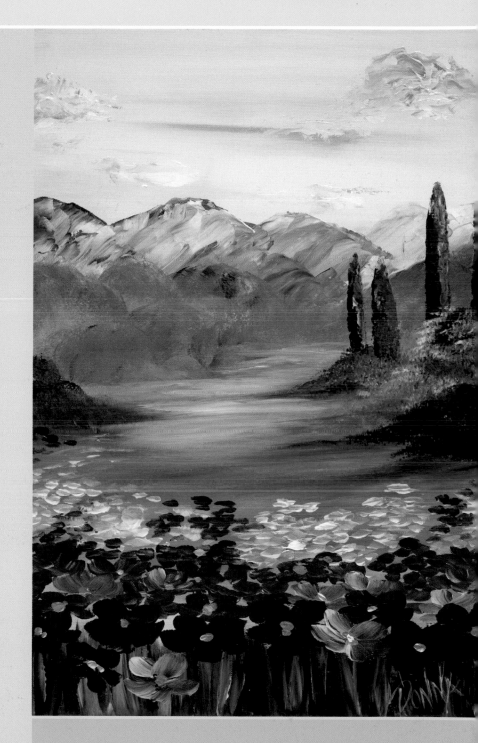

Materials

PAINTS. For all the paintings in this book, I used a new paint made by Plaid called FolkArt High Definition (HD) Visual Texture acrylic paint. This paint was specially developed to be thicker and more robust than the usual acrylic paints. It allows the artist to create beautifully realistic textures right on the canvas using a variety of tools.

With standard acrylics, texture is achieved by building up layer after layer of color using a brush. With High Definition paints, you can use a palette knife to lay the paint down thickly, almost like old-fashioned textured plaster on a wall. Or you can thin it with HD Clear Medium and use a sponge to apply large areas of color to your canvas. Once the paint is on your canvas you can move it around with the edge of your palette knife, almost like icing a cake. Or you can texture it further by pouncing it with a scruffy brush. HD paints can be double- and multi-loaded just like any other paint, which makes one-stroke landscape painting just as easy and fun to do! They are odorless and water-based so they clean up with soap and water.

BRUSHES. The HD brushes used in this book were developed to be used with the High Definition paint. They are larger than the classic One-Stroke brushes and have longer handles and brass ferrules. The longer handles are designed to allow you more freedom of movement for painting landscapes and other large subjects on canvas or other surfaces. If you've ever watched someone painting a landscape out in the open air, you may have noticed how they hold their brush. They do not grip it tightly down by the ferrule. Instead, they hold it loosely about halfway back on the handle and they use their whole arm to move the brush back and forth.

Loading the HD brushes with paint is the same as for any other brush; however, the bristle area is larger to pick up and hold more paint, which lets you cover large areas of canvas in a few strokes. To remove a color from your brush, just wipe it off on a paper towel. Don't swish it out in water every time you want to change colors. Wait until you are finished painting, then clean them out with cool water and some soap or brush cleaner.

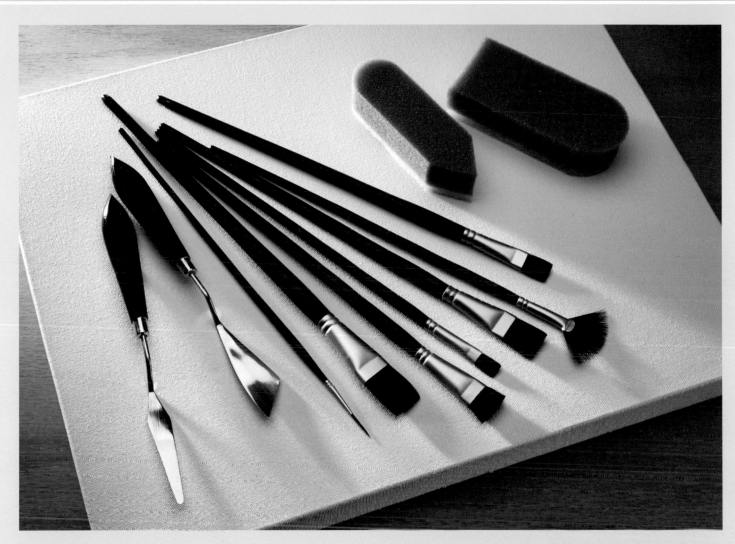

PALETTE KNIVES AND SPONGE PAINTERS. If you have never before used a palette knife to paint with, you are in for a treat! Palette knives have thin, flexible metal blades in different shapes, sizes and lengths. In this book, I used both wide and narrow palette knives to apply paint thickly to the canvas and to move it around. One of the most fun things to do with a knife is to paint mountains. Turn to page 29 to see how easy it is to paint the angular slopes of mountains and hillsides using palette knives that are double loaded with two or more colors just like a brush! You can use the flat of the knife or you can use the edge and the tip to achieve all sorts of special effects. Palette knives have been used by artists for hundreds of years. The next time you visit an art museum, check out the landscapes painted by the old masters. You will see lots of thick paint that was applied and textured using palette knives.

Sponge Painters are cellulose sponges that have either a rounded or pointed end and are available at art and craft supply stores. I use them with thinned paint to cover large areas of canvas quickly, such as skies, hillsides, lakes and oceans, among other things.

CANVAS. All the landscapes in this book were painted on pre-stretched canvases by Fredrix, available at art and craft supply stores everywhere. "Pre-stretched" means the canvas material has already been stretched flat and stapled to wooden stretcher bars, which lets you begin painting right away and saves you time and effort. The Fredrix Creative Edge canvases are made with especially wide edges that are staple-free, which allows you to continue your landscapes over the edges on all four sides. They are ready to hang when you are finished painting—no expensive frames are needed!

OTHER SUPPLIES. You will also need a few other common painting supplies to complete the landscape painting projects in this book. Keep folded paper towels next to your palette for wiping off your brushes. Use a pad of glossy palette paper to place your paint colors on. And don't use water to thin the High Definition paints—instead use FolkArt's HD Clear Medium, which comes in a handy squeeze bottle and is available wherever HD paints are sold. Or see the Resources section on page 134 for information on where to buy.

Getting Started in Landscape Painting

How to Hold and Use the Brush

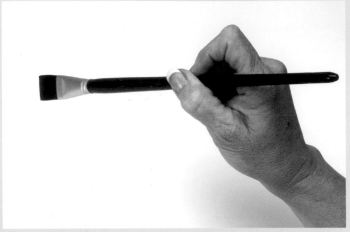

This is the large 1-inch (25mm) flat brush I use to paint landscapes on canvas. To hold the brush properly, grasp the long handle about halfway back and relax your hand. Don't grip it too tightly or too low on the handle—that will prevent the freedom of movement needed to paint large areas of the canvas in a few strokes.

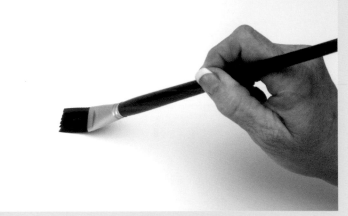

To cover a lot of ground easily, turn your brush so the flat side of the bristles lie on the surface of the canvas. Stroke back and forth just as you would with any flat brush. The bristles of this brush pick up and hold a lot of paint so you won't run out mid-stroke!

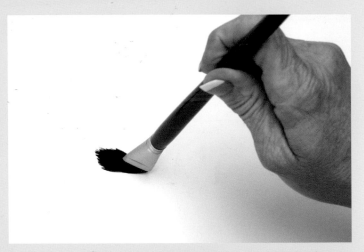

Now turn your brush so the narrow side is next to the surface and press down hard. The bristles will splay out into this triangular shape and allow you to paint into corners. You can also paint narrower lines than you can using the flat side of the brush.

When the instructions in the demonstrations say to paint "using the chisel edge" of the brush, hold the handle straight up, touch the very tips of the bristles to the surface of the canvas and press down slightly as shown here. Draw the brush toward you. This produces a thin line, perfect for painting tree branches, vines, little flower petals, and so on. Turn the brush so the bristles are horizontal and use the chisel edge to paint tiny waves and shimmery movement in water. Paint a pointed leaf or petal by "lifting to the chisel edge" at the end of your stroke.

Double-loading a Flat Brush with Paint

1 First, place a couple of dollops of paint on your palette, then squeeze out a small puddle of HD Clear Medium. Medium is white when it comes out but dries clear and does not affect the color of the paint.

2 To double load a flat brush, first dip one corner of the bristles into your first color. Hold the brush at an angle so only the corner is in the paint.

3 Turn the brush over and dip the other corner into your second color.

4 This is how a double-loaded flat brush should look when it is correctly loaded. Every time you pick up more paint on your brush, make sure you load it this way.

5 Now work the paint into the bristles by stroking back and forth on your palette to blend the colors. Keep loading and blending until the bristles are two-thirds full with paint.

6 To multi-load your brush, pick up a small amount of a third color on one corner. Here, I'm picking up Berry Wine on the red corner.

7 Again, blend the colors by stroking back and forth on your palette. Here you can clearly see the three different colors.

8 If you need to thin your paint, or if your brush seems dry or is dragging on the canvas, pick up a little Clear Medium after you have loaded your colors.

9 Blend the medium into your brush by stroking back and forth on your palette a few times. This will thin the colors and make them more transparent on your canvas.

Double-loading a Scruffy Brush and a Sponge Painter

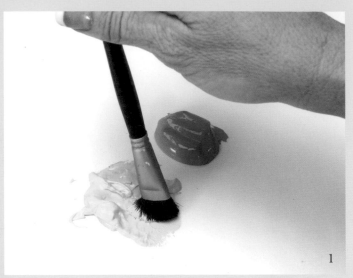

1 A scruffy is double-loaded differently than a flat brush. Never dip the scruffy into the middle of the paint puddle. Instead, pounce the scruffy at the edge of the puddle to load half of the bristles with the first color.

2 This shows that only half of the bristles are loaded with paint so far.

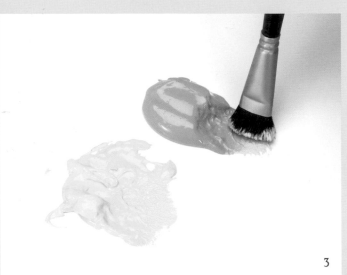

3 Now pounce the other side of the scruffy into the edge of the puddle of the second color.

4 Now you can see that the brush is evenly loaded with the two paint colors.

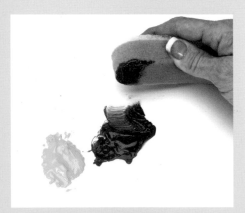

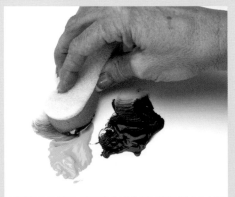

5 A sponge painter can be double loaded just like a brush. First, pick up some Clear Medium if needed, then touch one end into the edge of the puddle of your first color.

6 Load your second color by pulling paint from the edge of the puddle, holding the sponge at a slight angle.

7 This is how your double-loaded sponge painter looks when properly loaded. I use this technique to paint large areas on my canvas such as skies and oceans. I use the edge of the flat end to draw a horizon line, and I use the flat side to sweep on background color.

Loading a Wide Palette Knife

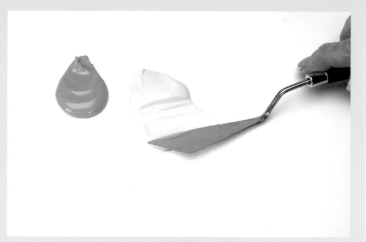

1 A wide palette knife has a flexible metal blade that is wider than usual and designed to pick up a lot of paint in one scoop. You can control how much paint you pick up by using the edge of the knife to first pull some paint out from the edge of the puddle.

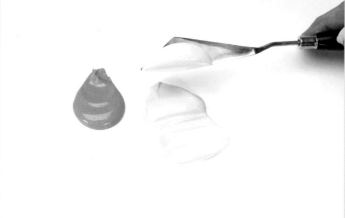

2 Scoop the paint onto the bottom of the blade from the edge of the puddle, not the middle. This is about how much paint should be on the blade if you are loading just a single color. Note that the blade is not entirely covered with paint—you can still see the pointed tips and the inside edge.

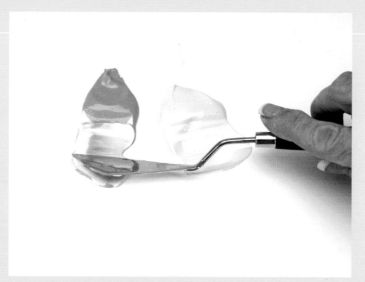

3 To double load a wide palette knife, turn the blade back over and pull some paint out from the edge of the puddle of the second color, just as you did for the first color.

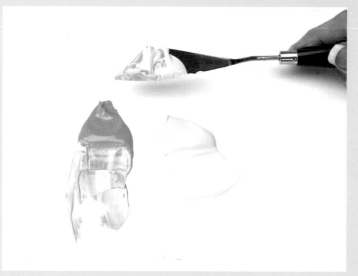

4 Now you can see the two colors properly loaded on the bottom of the blade. Because the High Definition paint we're using is thicker than regular acrylic paints, it won't drip or run off your knife. You can load your knife on the palette and move to the canvas without losing any paint!

Loading a Narrow Palette Knife

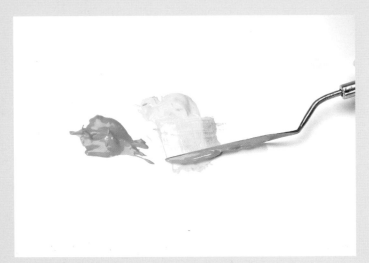

1 I load a narrow palette knife differently than I do the wide knife simply because the blade is long and narrow and therefore holds less paint. First, tap the bottom of the blade into your first puddle of paint.

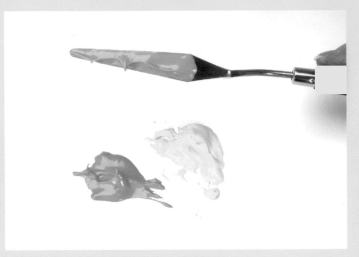

2 Tap all the way up to the tip so the entire bottom is covered. Again, the High Definition paint is thick enough that the paint won't run or drip off your knife.

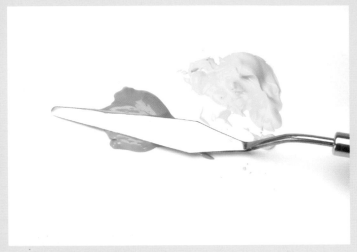

3 If you want to double load your narrow palette knife, turn the blade to its outside edge and pull from the edge of the second color using a gentle scraping motion of the tip end.

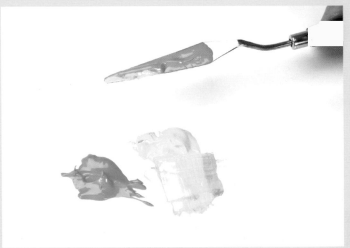

4 This is how a narrow palette knife looks when it is properly double loaded. I use this technique to apply thick paint anywhere there is an area too small for a brush or the wide knife or where I need to add details. The rounded point of the tip makes it easy to get into tight places.

Palette Knife Painting Techniques

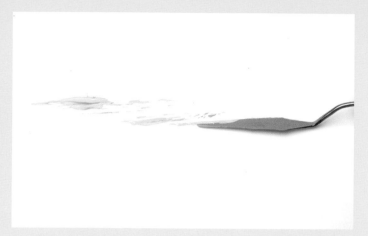

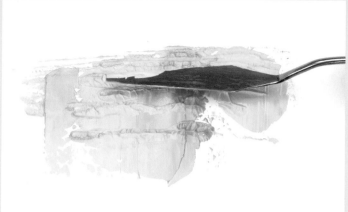

1 You can achieve several interesting effects using a palette knife because of its shape and the different kinds of edges it has. Here, I'm using one of the long thin edges to tap on narrow lines of paint, a great way to create distant hills or fields or waves in water.

2 To add texture to a painted area, while the paint is still wet, tap the bottom of the blade lightly into the paint to lift it up into little pebbles and points. Try this if you have large grassy areas that need some interest.

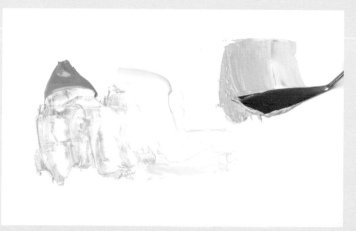

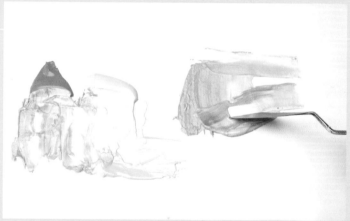

3 I often use a wide palette knife to blend large amounts of color on my palette—it's faster and easier than using a brush because you can scrape up the paint and turn it over and over until it is smooth and evenly blended, much like using a spatula in a bowl of batter.

4 Once your colors are blended on the palette, wipe off the knife using a paper towel. Come back to your color mixture and pick up a small amount on the edge of the blade.

5 Use the edge of the wide palette knife to draw vertical or horizontal elements such as tree trunks and branches, tall flower stalks, and anything that needs to look rough and uneven.

Painting on Multiple Canvases

2 or 3 Canvases Side by Side

1 To make a bold statement with your landscape paintings, try painting them across two, three or even four canvases! Many of the landscapes in this book are done on multiple canvases (see pages 86-87 for display ideas). Start with two vertical canvases like these. Each one is 18 x 24 inches (.46m x .69m).

2 Push them together so you can see the final size and shape.

3 Sponge on your background colors across both canvases.

4 If your canvases have staple-free edges like these, continue sponging paint over all four edges of each canvas. This gives a finished, gallery-style look to your artwork and no frames are needed.

5 If you want to paint a panoramic scene such as an ocean, you can make an extremely horizontal shape using three square canvases. These three are each 16 inches (.41m) square.

6 Push them together to see the final size and shape. (If you want to create a tall, narrow painting, stack the three canvases vertically.)

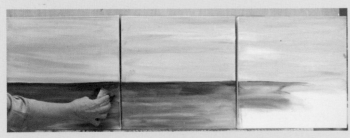

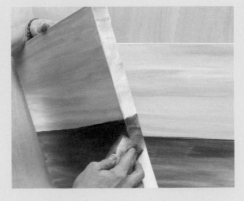

7 Sponge on your background colors carrying them across all three canvases.

8 If your canvases have staple-free edges like these, continue sponging paint over the edges on both sides, and the top and bottom of each canvas. This gives a finished look to your painting.

WITH A FLAT BRUSH

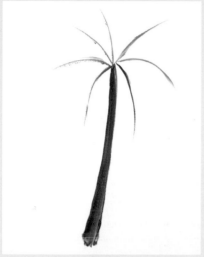

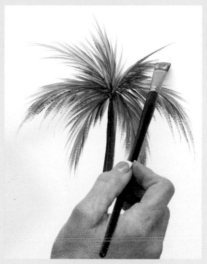

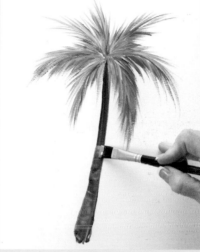

1 Paint the palm tree trunk with Burnt Umber and Wicker White double loaded on a flat brush. Draw the main stems of the palm fronds with Thicket on the chisel edge of the flat.

2 Use the chisel edge of the flat double loaded with a dark green and a light green to stroke the palm leaves extending downward and upward from both sides of the stems.

3 Highlight the palm fronds with a little yellow or a little white. Detail the growth segments on the palm trunk with white and yellow ochre double loaded on the flat brush.

FLAT

WITH A FAN BRUSH

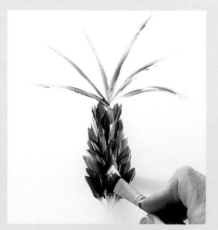

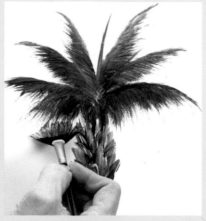

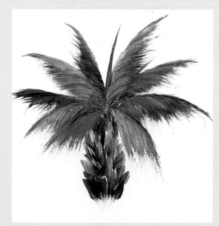

1 Place in the trunk of the short palm using angled chisel-edge strokes. Draw the stems of the palm fronds with Thicket.

2 Pick up a dark and light green on the chisel edge of a no. 4 fan brush and stroke the palm leaves extending downward from the stems.

3 Highlight the palm fronds with a little yellow or a little white using the chisel edge of the no. 4 fan brush.

FAN

19

WITH A FAN BRUSH

FAN

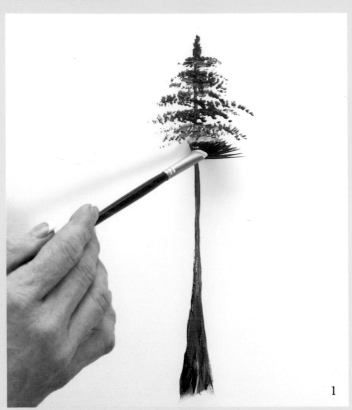

1

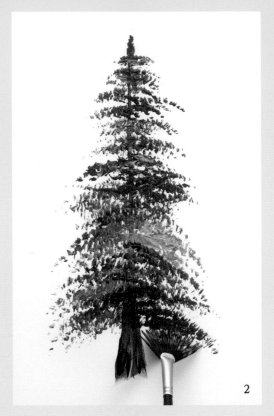

2

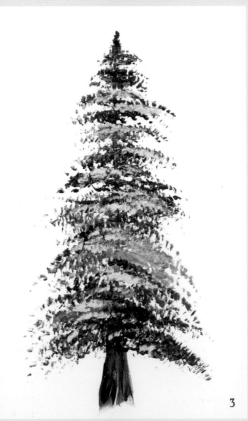

3

1 Here's the easiest way ever to paint an evergreen tree! First, use a flat brush to draw in the shape of the brown trunk. Then pick up a dark green and a light green on a no. 4 fan brush. Start tapping in the foliage at the very top, holding the brush vertically at first, then turning the brush horizontally and tapping with the corner of the fan brush for the narrow foliage coming down the trunk.

2 Pick up more dark and light green on the no. 4 fan brush and tap in the rest of the foliage. Hold the brush so the bristles are horizontal and lay almost flat to the surface. Make short arcs with the brush, widening the foliage as you near the base of the tree. Keep the foliage open and airy so you can still see the background through it.

3 Highlight the foliage with a little yellow using the chisel edge of the no. 4 fan brush.

WITH A SCRUFFY BRUSH

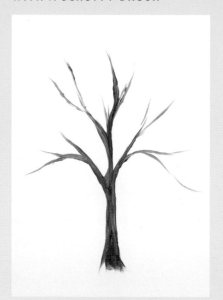

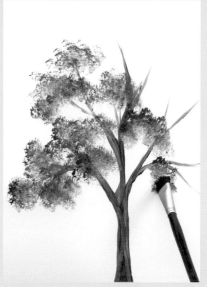

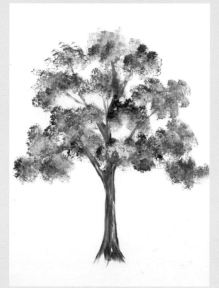

SCRUFFY

1 Deciduous trees, like maples and oaks which lose their leaves in the winter, can be painted very quickly using a scruffy brush for the foliage. Start by drawing in the trunk and branches with brown on a flat brush.

2 Double load a scruffy with a dark green and a yellow and pounce on clusters of foliage. Don't overdo it—let the branches show through here and there.

3 Shade some of the foliage with a dark green on the scruffy. Highlight one side of the trunk with a light brown and white using the chisel edge of a flat.

WITH A FAN BRUSH

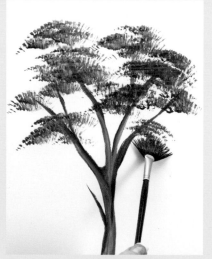

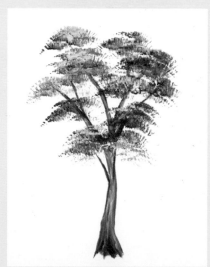

FAN

1 Deciduous trees with flatter clusters of foliage can be painted with a no. 4 fan brush. Start by drawing in the trunk and branches using a dark brown and white double loaded on a flat brush.

2 Pick up a dark and light green on the chisel edge of a no. 4 fan brush and tap on umbrella-like clusters of foliage that are slightly curved. Leave lots of open space between the clusters.

3 Highlight the foliage with a little yellow using the chisel edge of the no. 4 fan brush. Detail the trunk with white lines using the chisel edge of a flat brush.

4 Ideas for Flowering Shrubs

WITH A SCRUFFY BRUSH

SCRUFFY

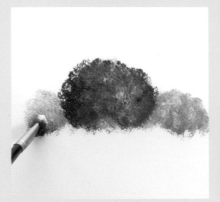

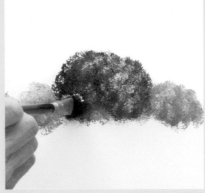

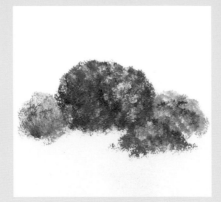

1 For a quick way to paint shrubs and bushes that have lots of small leaves, use your scruffy brush! Double load the scruffy in a dark green and a yellow and pounce on the foliage. Pick up more dark green on the brush for the center shrub.

2 Wipe off the scruffy on a paper towel and double load it with magenta and a bit of white. Pounce pink flowers on the center shrub.

3 Your pink flowers will look a little different depending on the shade of green you used for the foliage. The brightest pink is where there isn't any green foliage behind it.

WITH A FLAT BRUSH

FLAT

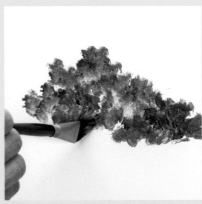

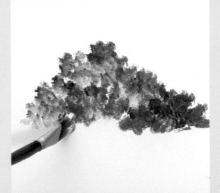

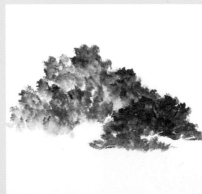

1 For a different look to your shrubs where the leaves may be larger or in clusters, use the chisel edge of a flat brush to dab on the foliage with a dark green and a yellow.

2 With ultramarine blue and white double loaded on the flat, use the same dabbing motion of the brush to add blue flowers here and there among the foliage.

3 To enrich the flower colors, pick up a dark violet and white on the dirty brush and dab on some purple flowers. The blue and purple flowers are brighter where they extend beyond the green foliage.

WITH A FAN BRUSH

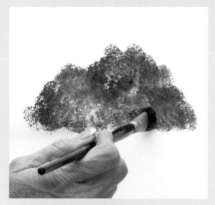

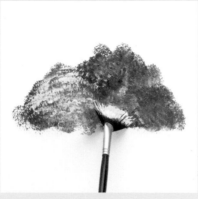

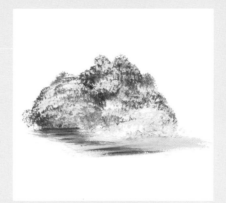

FAN

1 Painting flowering shrubs with a fan brush is another quick and easy way to add color to your landscapes. Begin by pouncing on the green foliage with a scruffy brush.

2 Load a no. 4 fan brush with a bright yellow and white and tap on rows of yellow blossoms. Use a curving motion as you tap so the yellow flowers look as if they are growing along each branch.

3 Fill in with more yellow flowers and let some of them cascade to the ground as if the branches are too heavy with blossoms to stay upright. Pick up some of your dark green foliage color and use horizontal strokes to shade under the shrub.

WITH A FAN BRUSH

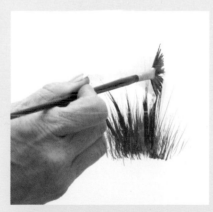

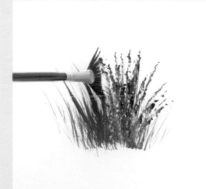

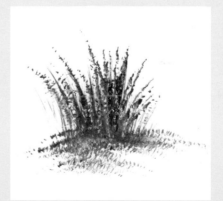

FAN

1 Here's an altogether different look using just the chisel edge of the fan brush. Load a dark green on the brush and, holding the bristles vertically, pull spiky leaves and stems upward from the ground.

2 Pick up a bright red and a little white on the tips of the bristles and tap on tall stalks of flowers starting at the bottom and going up the stems, keeping the bristles vertical.

3 Fill in with flower stalks, then pick up a dark and light green on the fan brush and dab on some green grass at the base of the plant, holding the brush horizontally and using the flat side of the fan's bristles.

WITH A PALETTE KNIFE

PALETTE KNIFE

1 In landscape painting, the sky is often a large part of the design. To lay in the sky colors, use horizontal motions of a sponge painter across the canvas. Dress the sponge in Clear Medium, then double load with ultramarine blue and white. Pick up more blue for deeper color, more white for less color.

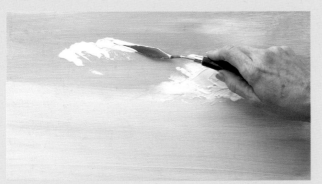

3 To give your clouds more dimension and texture, press on thick white paint and then tap the paint with the bottom of the knife to lift it up here and there.

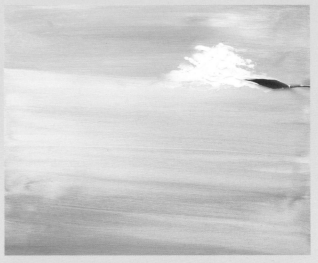

2 Load the bottom of a narrow palette knife with white. Using a pressing motion, press the paint to the canvas, then smooth it out into random cloud shapes, as if you were icing a cake.

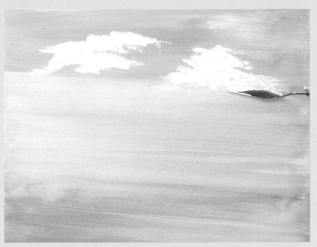

4 To soften some of the edges of the clouds so they fade away into the sky color, use the edge of the knife to pull the white paint out into the blue area. Leave some of the cloud edges well defined, and soften others for a more natural look.

WITH A SPONGE

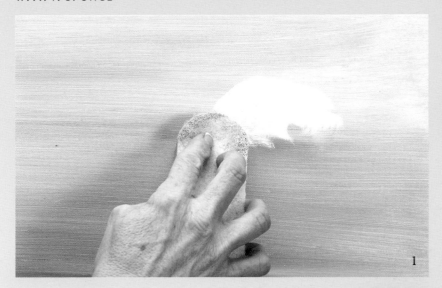

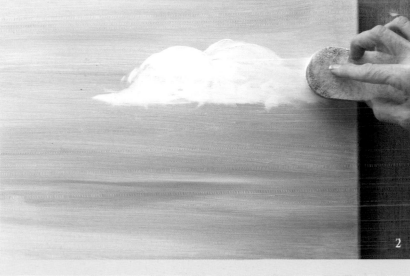

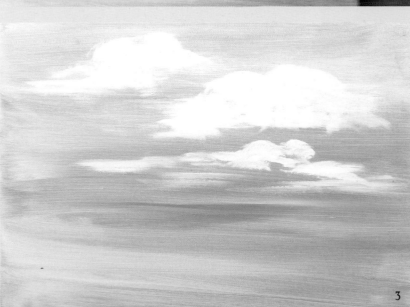

1 Painting clouds with a sponge is faster than using a palette knife, but they'll be smoother and a little less textured. Pick up white paint on the same sponge you used to place in the blue sky colors and use the rounded end to begin drawing the cloud shapes. Make them puffy on top and flatter along the bottom.

2 Once you have your cloud shape, stroke lightly across it with the flat of the sponge, barely touching the paint to soften the edges and blend them out.

3 Fill in with more clouds as needed. The flatter clouds are drawn with the edge of the sponge for more control. Sweep lightly across them to pull thin wisps of white out into the blue color along the bottom and outer edges. Keep the cloud tops pretty well defined.

SPONGE

WITH A SPONGE

SPONGE

1 Sunset colors can vary widely depending on the location and the weather. This sunset's hot colors suggest a desert setting to me. Load Pure Orange on a sponge, pick up some Clear Medium and stroke in the sky color using horizontal motions across the entire canvas.

2 Load Engine Red on the sponge and stroke across the top of the canvas horizontally, then pick up Berry Wine and stroke this in the red area to darken. As you move down the canvas, stroke in more red, pick up Pure Orange on your red sponge and stroke across, then pick up Yellow Light and stroke horizontally in places where the sunlight is shining through the clouds.

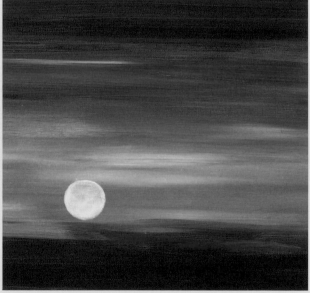

3 Along the bottom third of the canvas, stroke in Engine Red across the canvas. Blend this area upward into the yellow sunlit area with Pure Orange on the dirty sponge.

4 The orb of the setting sun is painted with Yellow Light and some Wicker White. (Yellow Light is a transparent color so the Wicker White helps make it more opaque for better coverage.) Dress a no. 12 flat with Clear Medium, load the yellow and white, and draw the circle in two half-circle strokes.

WITH A SPONGE

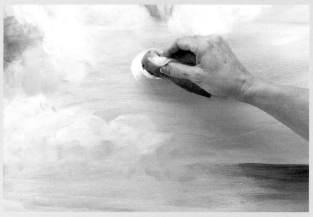

SPONGE

1 Sunsets can also be very subtle, with cooler colors and just a hint of yellow such as in this ocean scene. Load Periwinkle and Wicker White on a sponge painter, pick up some Clear Medium and stroke in the sky color using horizontal motions across the canvas. Alternate this color with Calypso Sky and Brilliant Ultramarine as you sponge in the sky. Carry these background colors all the way to the bottom of the canvas. Establish the horizon line of the ocean with Brilliant Ultramarine coming in from the right side of the canvas.

2 Pick up more Wicker White on your dirty sponge and begin placing in the puffy clouds. Use circular motions to get the basic shape, then use the flat of your sponge and lateral motions to soften the clouds and blend out their edges.

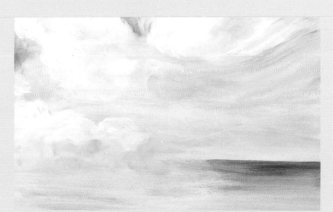

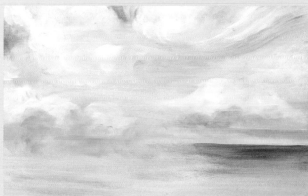

3 Among the puffy clouds are streaks of cirrus clouds. Load a sponge with medium, Brilliant Ultramarine and Wicker White and stroke in the wispy cirrus clouds with curving strokes coming down from the top right toward the center. Pick up a tiny amount of Yellow Light and use curving strokes to indicate sun reflections.

4 Work some Yellow Light into the distant sky just above the horizon line to suggest the light of the setting sun. Above this, place some more puffy white clouds and darken their bottoms with thinned Ultramarine Blue. The blue contrasts with the yellow of the sunset, making it the focal point of the painting.

2 Ways to Paint Rolling Hills and Rocky Mountains

WITH A SPONGE

SPONGE

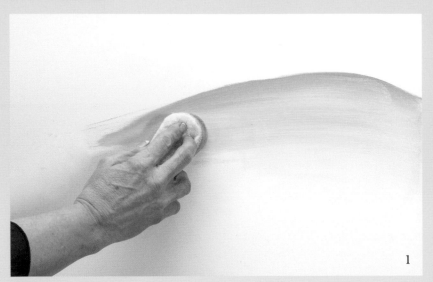

1

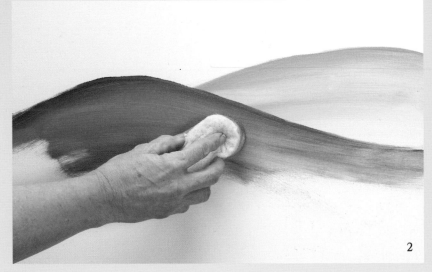

2

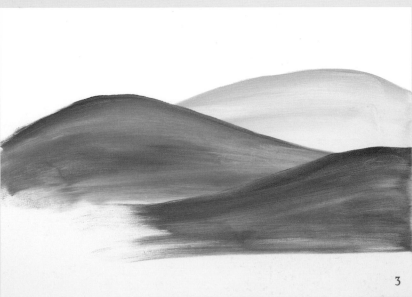

3

1 This is an ideal technique any time you need to paint rolling hills, distant fields, large grassy areas, and so on. The sponge painter is the best tool for this because you can create long sweeps of color and shape in just a few strokes. For autumn-colored hills like these, pick up Clear Medium on the sponge, then double load with Yellow Ochre and Sunflower. Draw the line of the most distant hill with the edge of the sponge, keeping the Yellow Ochre to the top to define the ridgeline, then fill in with the flat of the sponge.

2 Load the dirty sponge with Berry Wine or some other darker color and sweep in the hill in the middle distance, starting at the left and stroking to the right. Keep the Berry Wine to the top to clearly define the ridgeline, then fill in with the flat of the sponge.

3 Pick up a darker brown on the dirty sponge and sweep in the foreground hill, starting at the right and stroking to the left. Again, define the ridgeline with the brown edge of the sponge.

Note that the farther away the hill is, the lighter in color it is. This is true no matter what colors you use. For green hills, the most distant hill would be a light gray-green or blue-green. The change in colors and values helps create the illusion of depth and distance.

WITH A PALETTE KNIFE

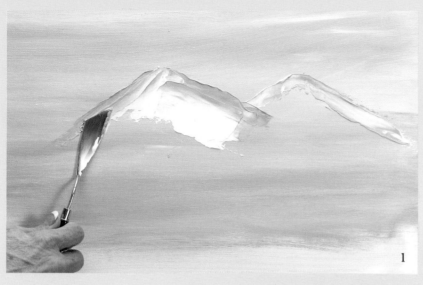

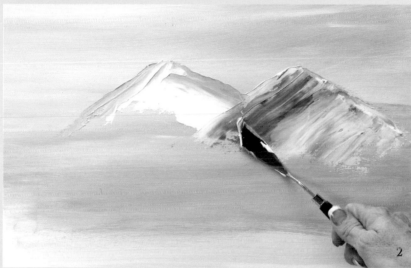

1

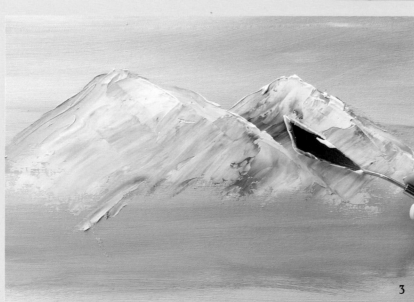

3

1 Using a palette knife to paint rocky mountains is not only fun—it's the best way to quickly achieve lots of texture and color variation, and to clearly define the sharp ridgelines, peaks and valleys. Start by sponging in your background colors. Then double load a wide palette knife with Butter Pecan and Wicker White (see page 13 for instructions on loading a wide palette knife). Use the edge of the knife to draw the main shapes of the peaks, letting them overlap as shown here.

2 Pick up Burnt Umber on your knife and slide the blade in a diagonal motion to create the steep slopes of the mountainsides. Use thick paint for lots of texture and to give the look of rough, craggy rocks. Keep picking up more paint every time you stroke. Pick up more Burnt Umber sometimes and more Butter Pecan other times for natural color variations, and be sure to move the blade in the same general diagonal direction every time.

3 To define the upper ridgeline and to separate the overlapping mountains, use the edge of your knife to draw the ridgeline, then the flat of your knife to fill in. If you want to apply a little snow at the tops of the peaks, pick up Wicker White on your palette knife, lay the edge down along the line of the peak and pull downward in the same diagonal stroke used for the mountain slopes.

4 Kinds of One-Stroke Leaves

WITH A FLAT BRUSH

FLAT

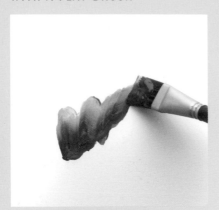

1 Ruffled-edge leaves have scalloped edges with deep lobes. Double load a flat brush with a dark green and a light yellow or white. Keeping the dark green to the inside, start at the base and paint the first half of the leaf, turning and lifting to the chisel at the tip.

2 Turn the brush over so the dark green is again to the inside and paint the second half of the leaf the same way, lifting to the chisel and pulling to a sharp point at the tip.

3 Pull a curving stem halfway into the center of the leaf. Stay up on the chisel edge of the brush and use only light pressure.

WITH A FLAT BRUSH

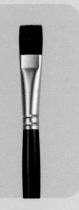

FLAT

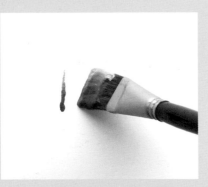

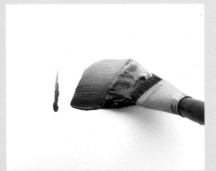

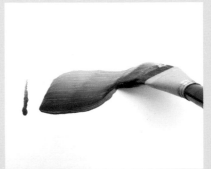

1 A basic one-stroke leaf is created with a single stroke of the flat brush. Double load the flat with a green and a yellow. Touch the chisel edge down to use as a guideline when you're practicing one-stroke leaves.

2 Press down on the bristles to fan them out slightly and begin pulling the stroke.

3 Lift back up to the chisel edge and pull the leaf to a point at the tip.

WITH A FLAT BRUSH

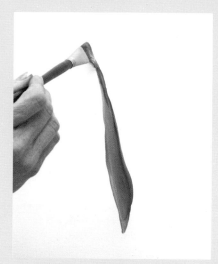 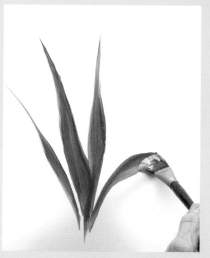 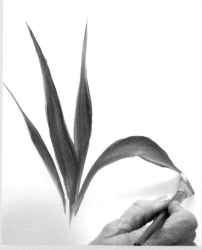

FLAT

1 Spiky leaves are painted with long vertical strokes. Double load your flat brush with a dark green and a yellow, start at the base and push down on the bristles to widen the stroke. Gradually release pressure as you go upward, lifting to the chisel at the tip.

2 Add more spiky leaves to fill out, starting in the same place at the base and extending the tips into sharp points. For a natural look, make some of the leaves wider and some skinny, and add a drooping leaf to one side. This leaf is widest where it starts to fold over.

3 Finish the drooping leaf by turning your brush and reversing direction downward. Gradually release pressure on the brush, then lift to the chisel as you pull to a pointed tip.

WITH A FLAT BRUSH

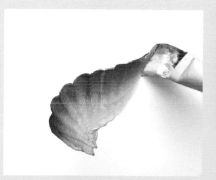

FLAT

1 Wiggle-edge leaves have small scallops along each edge. Double load a flat with dark and light green. Start at the base with the dark green to the outside edge, and wiggle the brush as you stroke upward. Turn and lift to the chisel to form a point.

2 Turn the brush so the dark green is to the outside edge of the other half of the leaf. Start at the base again and wiggle the brush as you stroke upward. Turn the brush, lift back up to the chisel and pull to the tip.

3 Finish by pulling a curving stem halfway into the center of the leaf. Stay up on the chisel edge of the brush and use only light pressure.

2 Types of Dried and Autumn Leaves

FLAT

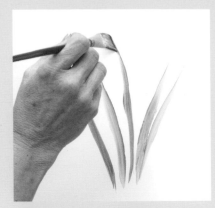

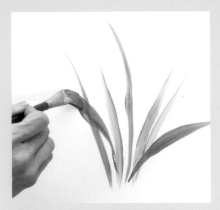

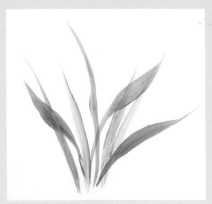

1 Dried leaves can add interest to ordinary-looking plants. The key is to use a lot of Clear Medium to thin the paint so the leaves have a transparent, almost shadowy look. Dress a flat brush with medium, double load a brown and a little bit of dark green, and pull a long, thin, spiky leaf.

2 For wider leaves, push down harder on the brush to widen the middle of the leaf before lifting to the chisel and pulling to a point at the tip.

3 Keep picking up more medium every time you reload your brush to thin the paint. Here you can see the green leaves through a couple of the dried brown leaves. This adds dimension and liveliness to your painting.

WITH A FLAT BRUSH

FLAT

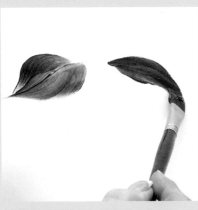

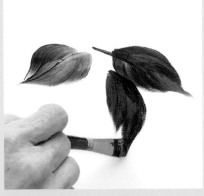

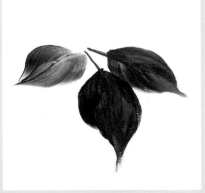

1 Autumn leaves are fun to paint because they come in so many colors. The leaf on the left is painted with thinned Burnt Umber and a little Forest Moss. The one on the right is thinned Burnt Umber and Berry Wine.

2 Paint the red leaf with thinned Engine Red and Berry Wine double loaded on a flat brush.

3 If your paint has been thinned with medium and is still wet, you can often restroke the leaves a few times to get interesting streaks and textures.

4 Easy One-Stroke Flowers

WITH A FLAT BRUSH

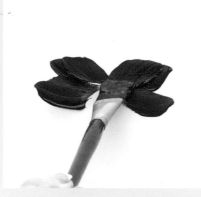

FLAT

1 Red poppies are one of today's most popular flowers to paint. I added a whole field of them to the demo "Poppies in the Sierra" on pages 96-97. Double load Engine Red and a little Green Forest on a large flat and stroke each petal in toward the center.

2 Pick up Yellow Light on the dirty brush and tip the corners of the outer petals with a small curving stroke to highlight.

3 Finish with a center of Periwinkle and Wicker White dabbed on with the corner of the flat brush. Adding white to the Periwinkle brightens the color and helps cover the red of the petals in the center.

WITH A FLAT BRUSH

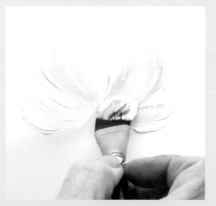

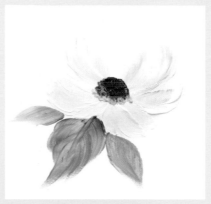

FLAT

1 White cosmos or other white flowers add freshness to any landscape painting, as you'll see in "Through the Garden" on page 102. Double load a flat with Wicker White and a touch of Yellow Citron and stroke each petal in toward the center.

2 Turn your work to make painting the lower petals easier if needed. Keep your paint thick on your brush—the texture provides shape, separation and visible edges to each petal.

3 Finish with a center of Burnt Umber and Yellow Citron dabbed on with the corner of the flat. The pollen dots are Yellow Light and the leaves are Yellow Citron.

4 Easy One-Stroke Flowers

WITH A FLAT BRUSH

FLAT

1

2

3

1 Yellow daisies are quick to paint and can make a landscape painting almost sparkle with sunlight and color, as you'll see in the demo "Fields of Daisies" on page 128. Double load a small flat brush with Yellow Light and Wicker White and pick up a tiny amount of Yellow Ochre on the yellow corner of the brush. Each petal is simply a comma stroke pulled in toward the center. The petals to the side are more curved; the ones to the front are straighter and shorter.

2 Load lots of paint on your brush to add texture to the petals, and vary the shapes and direction of the daisies—some looking toward you, some facing up, some seen from the side. Pull thin stems of Green Forest or Thicket starting underneath the petals and stroking downward using the chisel edge of the brush.

3 Just for fun, add centers in colors you don't normally see. These centers are Periwinkle and Wicker White dabbed on with the flat brush. Add shading to some of the centers using Brilliant Ultramarine. The blues of the centers are complementary colors to the yellows of the petals, providing the contrast needed to make all the colors pop!

WITH A FLAT BRUSH

FLAT

1 Bird-of-paradise is an exotic flower found mainly in hot, tropical areas. I used it as a point of interest in "Postcard from Hawaii" on pages 116-117. Double load a large flat with Pure Orange, Yellow Light and Wicker White. Paint orange flower petals with pointed tips.

2 Pick up more paint for each petal to vary the colors and keep the paint thick and textural. The purple flower petal is painted with Violet Pansy on the dirty brush.

3 Wipe your brush on a paper towel, pick up Green Forest and Engine Red and paint the large dark pod from which all the colorful petals emerge. Wipe your brush on a towel again and pick up Green Forest and Yellow Light and paint the thick green stem, stroking downward from underneath the orange petal.

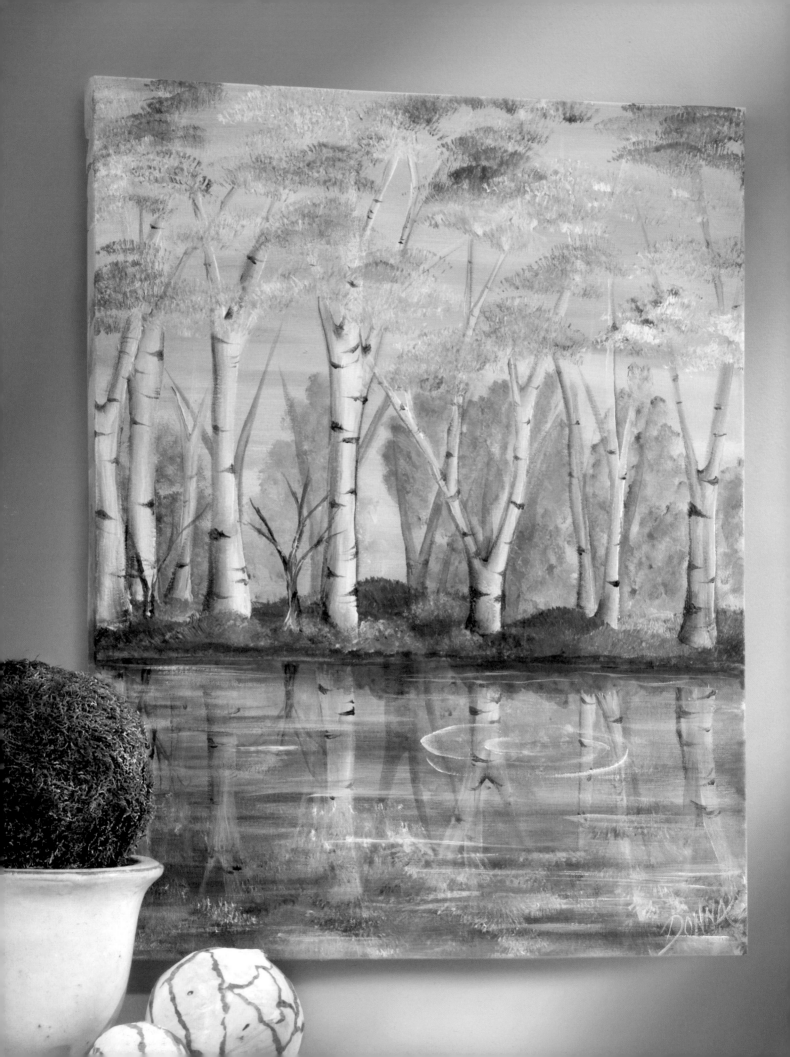

Painting on a Single Canvas

LET'S BEGIN OUR ADVENTURES in landscape painting with some subjects that are designed to look striking on one single canvas. You will need one 18 x 24-inch (.46m x .69m) canvas for each of the eight projects in this section. I used the Fredrix Creative Edge gallery-style prestretched canvases because they have a wide edge on all four sides that is smooth and free of staples. This allows you to continue the painting onto the edges, giving your artwork a finished look and eliminating the need for an expensive frame.

To make it easier for you to think about and paint landscapes, I have divided the process into three parts:

1. Place in the background.
2. Paint the focal point.
3. Fill in with the details.

Each project is painted in this way. I always start by quickly placing in the background using either a sponge painter or a palette knife. Then I paint the focal point or center of interest. Finally I finish up by filling in the details. Once you get into the rhythm of painting this way, it becomes easy and fun—and the results are spectacular!

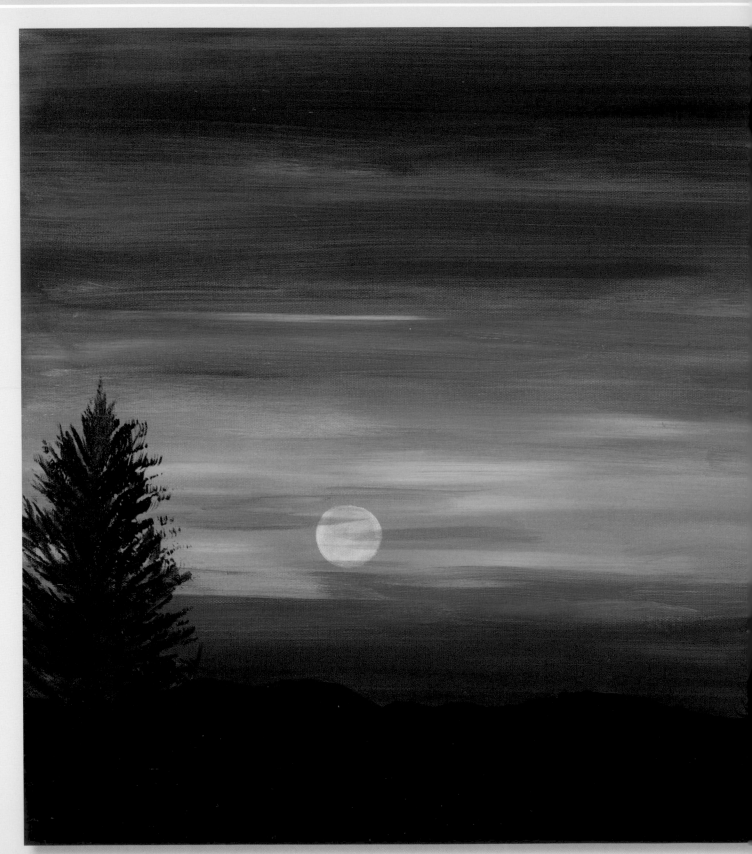

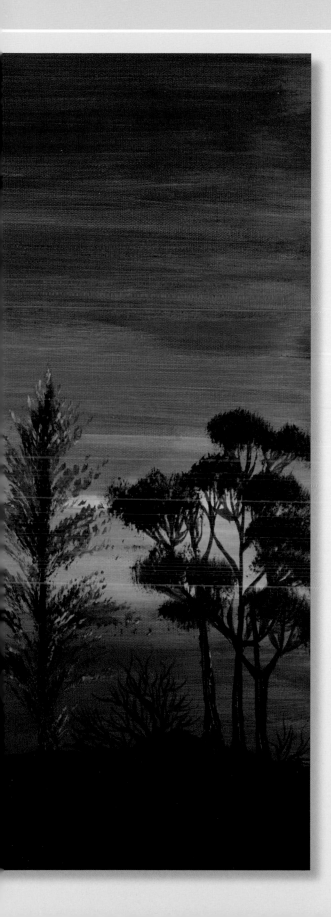

FOR OUR FIRST LANDSCAPE, let's begin with an easy-to-paint scene of a brilliant sunset and a few trees in silhouette. We'll use only a few colors, mostly in the sky, and a few brushes. You'll also enjoy using a palette knife to texture the hills and ridgeline.

BRUSHES
- no. 4 fan
- nos. 10 and 12 flats
- large scruffy
- no. 2 script liner

CANVAS
One 24 x 18-inch (.69 x .46m) stretched canvas, with 1½-inch (3.8 cm) thick, staple-free edges, by Fredrix Creative Edge

ADDITIONAL SUPPLIES
- FolkArt Sponge Painters
- FolkArt HD Clear Medium
- Narrow palette knife

FOLKART HIGH DEFINITION ACRYLIC PAINT

Pure Orange

Engine Red

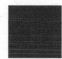
Berry Wine

Yellow Light

Licorice

Maple Syrup

Yellow Ochre Wicker White

Sponge On the Background

1 Load Pure Orange on a sponge, pick up some Clear Medium and stroke in the first sunset sky color using horizontal motions across the canvas. Carry this background color all the way to the bottom of the canvas.

2 Load Engine Red on a sponge and stroke across the top of the canvas horizontally, then pick up Berry Wine and stroke this in the red area to darken. As you move down the canvas, stroke in more red, pick up Pure Orange on your red sponge and stroke across, then pick up Yellow Light and stroke horizontally in places where the sunlight is shining through the clouds.

3 Along the bottom third of the canvas, stroke in Engine Red across the canvas. Blend this area upward into the yellow sunlit area with Pure Orange on the dirty sponge.

Paint the Focal Point

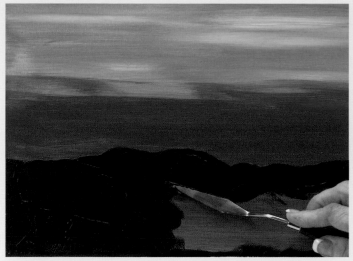

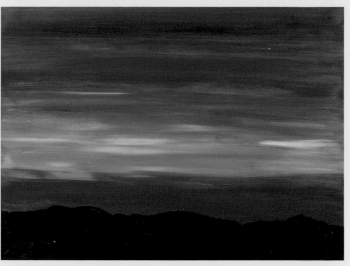

4 Use a narrow palette knife and Licorice to block in the silhouetted hills. The knife will give texture to this area, which contrasts with the smoothly sponged sky area.

5 Fill in the rest of the silhouetted hills using the palette knife and Licorice. Keep these hills low; they shouldn't dominate the scene.

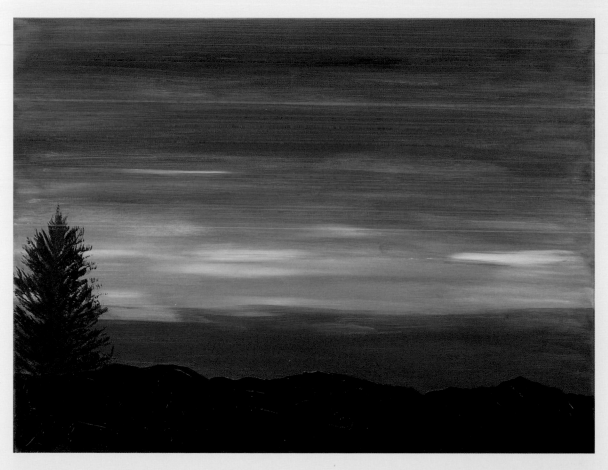

6 With a no. 4 fan brush and Licorice, tap in the branches of the silhouetted evergreen tree at the far left. Be careful not to fill in with too many branches; you still want to see the sunset colors through them.

Paint the Focal Point

7 Using the chisel edge of a no. 10 flat and Licorice, draw in the trunk and branches of the silhouetted tree on the far right. Load a scruffy with Licorice and tap in the foliage. Place in the trunk of the tall skinny tree next to it with Licorice on a no. 10 flat. Using Maple Syrup, Yellow Ochre and a touch of Licorice on a no. 4 fan, tap in the angled branches using light touches of the chisel edge of the fan brush. Keep the Yellow Ochre to the outside to show the tips of the branches being lit by the setting sun.

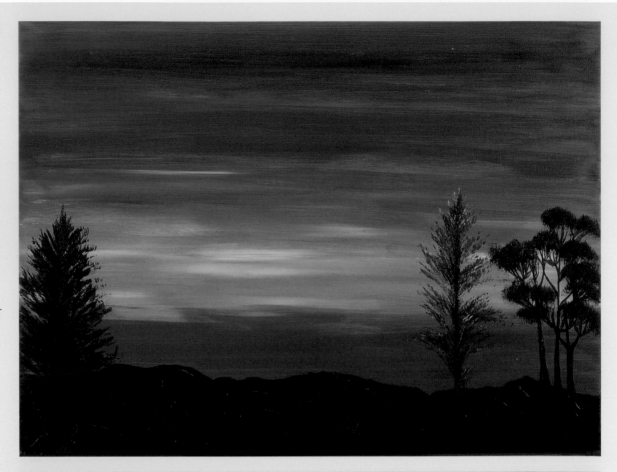

8 Load a no. 2 script liner with inky Licorice and paint the bare branches of the shrubs beneath the trees at the right. Keep these low and sparse so they don't take attention from the trees.

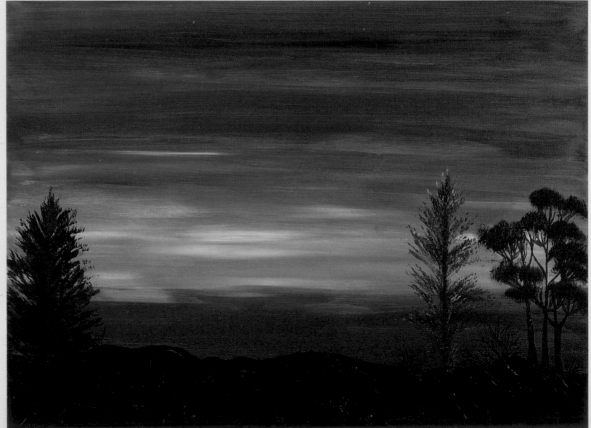

Fill In with the Details

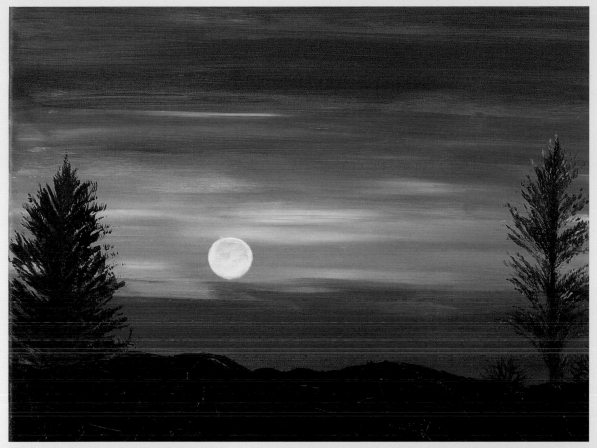

9 Paint the orb of the setting sun with Yellow Light, adding some Wicker White to it since Yellow Light is a transparent color. First dress your no. 12 flat brush with medium, pick up the yellow and white and use two half-circle strokes to draw the round shape of the sun.

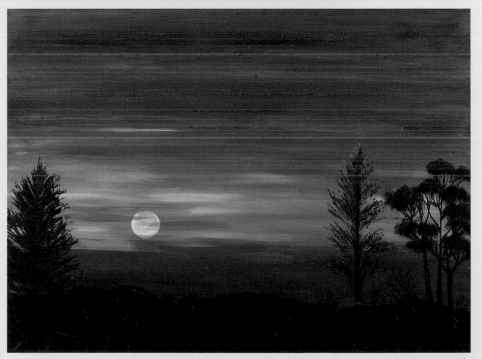

10 Streak Engine Red thinned with a lot of medium lightly over the edges of the sun to soften it and set it back in the sky.

11 Darken the lowest part of the sky along the top edge of the silhouetted hills with random streaks of thinned Berry Wine. Don't do this everywhere along the ridgeline; leave the sky red behind the silhouetted trees and shrubs on the right.

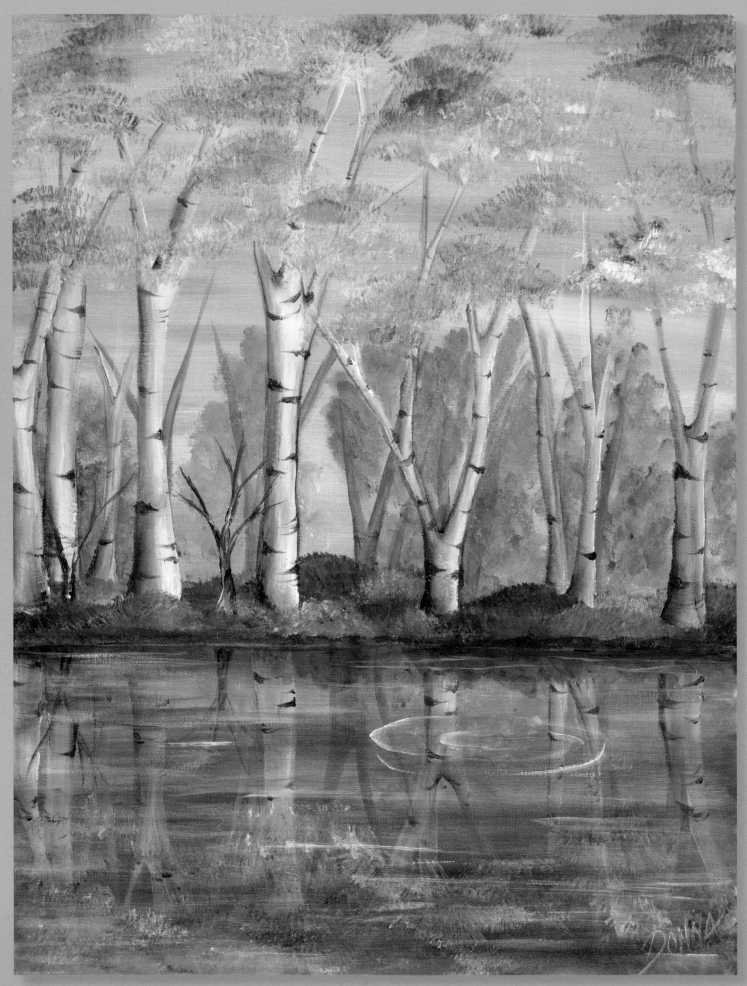

44

Birch Tree Reflections

BRUSHES
- ¾-inch (19mm) flat
- 1-inch (25mm) flat
- nos. 10 and 16 flats
- no. 4 fan
- no. 2 script liner

CANVAS
One 18 x 24-inch (.46 x .69m) stretched canvas, with 1½-inch (3.8 cm) thick, staple-free edges, by Fredrix Creative Edge

ADDITIONAL SUPPLIES
- FolkArt Sponge Painters
- FolkArt HD Clear Medium

ONE OF THE MOST INTERESTING things about birch trees is their lovely white bark that splits and peels revealing brown bark underneath. You'll see how to paint this in Step 8 of this demonstration using a script liner and Burnt Umber. I'll also show you how to paint the reflections of trees in still water. The secret is to paint the reflections at the same time you paint the actual trees. Each reflection is directly below its own tree—it doesn't shift position or lean in the opposite direction. It truly is a mirror image. I love discovering things like that about landscape painting, and it reminds me to look more closely at the natural world every time I'm out of doors.

FOLKART HIGH DEFINITION ACRYLIC PAINT

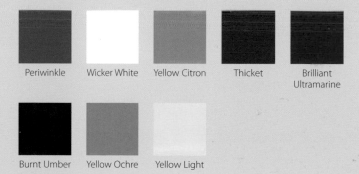

Periwinkle	Wicker White	Yellow Citron	Thicket	Brilliant Ultramarine
Burnt Umber	Yellow Ochre	Yellow Light		

Sponge On the Background

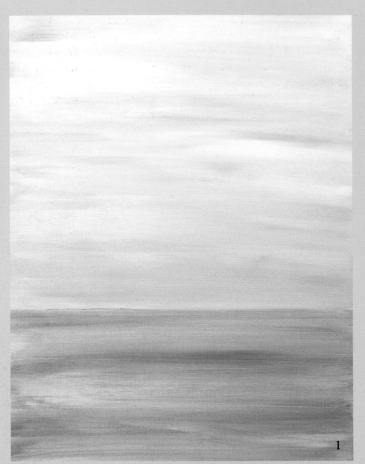

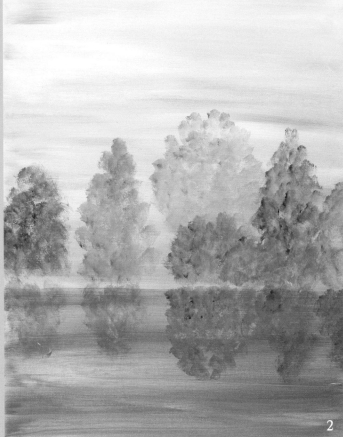

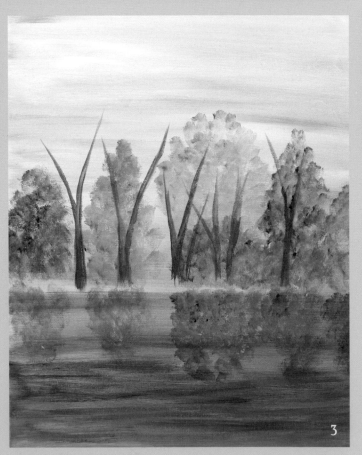

1 Double load Periwinkle and Wicker White on a sponge painter, pick up some Clear Medium and stroke in the sky color using horizontal motions across the canvas. Pick up more Periwinkle sometimes and more Wicker White sometimes to get color variations. Carry this color all the way to the bottom of the canvas, deepening the blue as you go below the line of the river banks using more Periwinkle.

2 With Yellow Citron and Thicket double loaded on a 1-inch (25mm) flat, dab on the foliage of the background trees and their reflections in the water. Keep this foliage light and airy and thin, especially in the reflections. This is just the background foliage; it needs to remain subtle and indistinct.

3 Deepen the blue of the foreground water with thinned Brilliant Ultramarine stroked on with a sponge that has been dipped into medium. Load a ¾-inch (19mm) flat with Burnt Umber, Wicker White and Yellow Ochre and paint the birch tree trunks in front of the background trees.

Paint the Focal Point

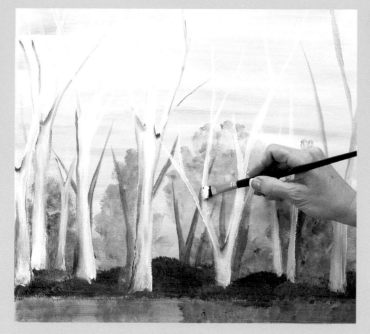

4 Place in the shrubs and bushes along the river bank with Thicket and Yellow Citron on a no. 4 fan brush. Highlight with little dabs of Yellow Light here and there. To paint the birch tree trunks and branches, load a no. 16 flat with Wicker White and stroke the trunks upward from the base, lifting to the chisel edge to thin out the branches as you come to their outer tips. After all the trunks are placed in, pick up a little Burnt Umber on your dirty brush and lightly shade along the sides and where the branches fork from the trunk.

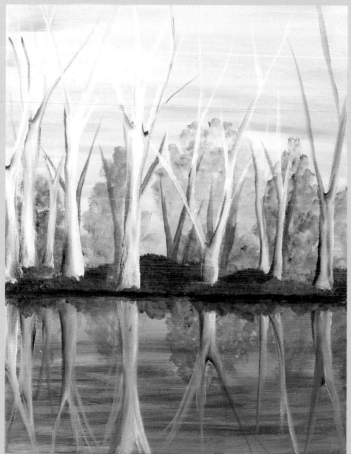

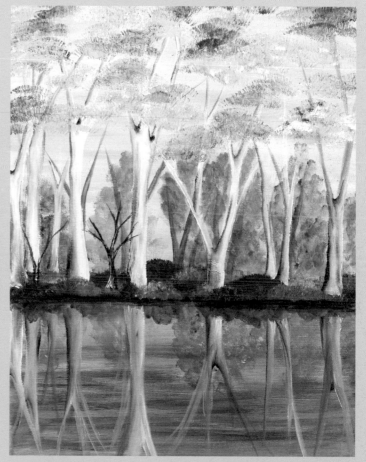

5 Load a ¾-inch (19mm) flat with Burnt Umber and medium and indicate the muddy river bank below the shrubs. Dab in the reflections of the shrubs using the same greens as in step 4. Paint the reflections of the birch tree trunks directly below the actual trunks using medium, Wicker White and Burnt Umber. The reflections are not as white as the actual birch trees, and they do not angle or bend in any way. They are separated from the trees by the muddy river banks and the shrubs.

6 With Burnt Umber and Wicker White double loaded on a no. 10 flat, paint the trunks and bare branches of the two small saplings at the left side. To paint the foliage of the tall birch trees, load a no. 4 fan brush with Yellow Citron and Yellow Light, sometimes picking up Thicket for the darker, shaded areas of foliage. If needed, darken some of the background foliage behind the white trunks to add contrast and help the white bark stand out more.

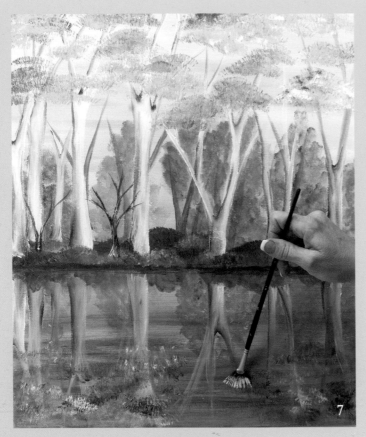

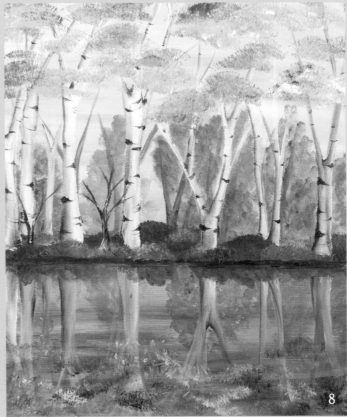

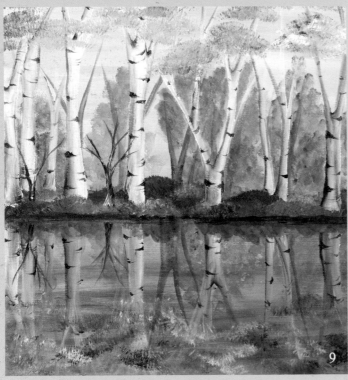

7 Paint the reflected foliage in the water by holding the no. 4 fan brush upside down and tapping on the same foliage colors you used in the previous step.

8 With Burnt Umber thinned with medium, paint the birch bark details using a no. 2 script liner. This is where the white bark has split apart or is peeling, revealing the darker brown bark underneath. Pull very thin curved lines inward from both edges of the tree trunks, and for some of the larger splits, make them triangle shaped.

9 Paint these same bark details on the reflected tree trunks, but use less paint and more medium to keep the brown color thinner and lighter. Remember that the colors of any objects that are reflected in water should always be more subtle than the actual colors.

Fill In with the Details

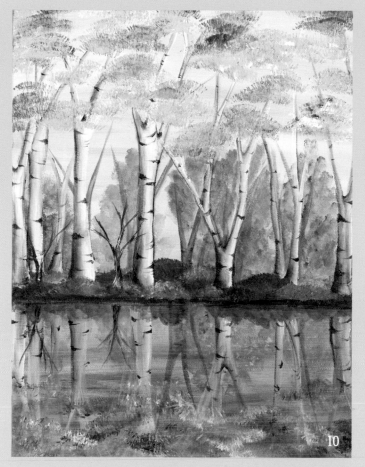

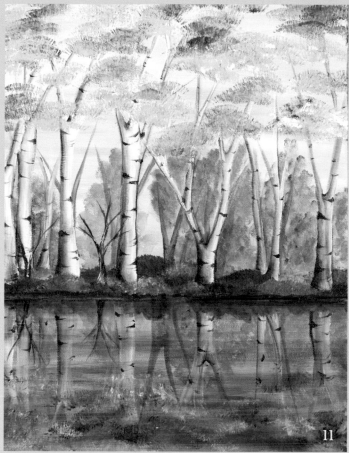

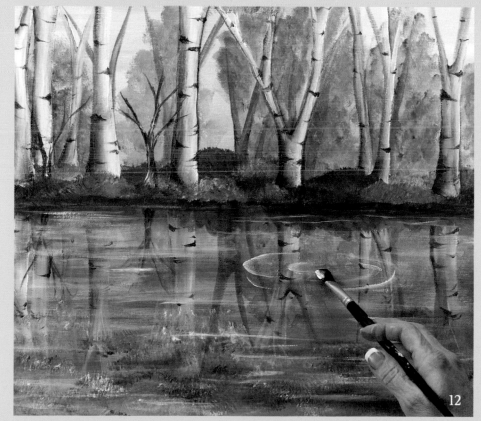

10 Enrich the shading color on the birch bark with Yellow Ochre thinned with lots of medium. Then come back in with Wicker White and highlight the sides opposite the shading on some of the birch trunks. This gives roundness and dimension to the trunks.

11 Dress a sponge painter with medium and pick up Brilliant Ultramarine. Stroke this thinned blue horizontally in the water right over the reflections of the trees. Keep this color darker next to the river bank where the water is in shadow.

12 Dress a ¾-inch (19mm) flat with medium and sideload into Wicker White. Use the chisel edge of the brush and very light pressure to streak in little waves indicating water movement. Place these white streaks sparingly and randomly in the water, but keep the motion of your brush horizontal. Add more medium to the brush and use the flat side to soften the reflections of the tree trunks and foliage in the water. If you wish, add a couple of circular wave lines to show bubbles coming up from underneath.

50

Sunrise in the Everglades

BRUSHES
- ¾-inch (19mm) flat
- 1-inch (25mm) flat
- nos. 12 and 16 flats
- no. 4 fan
- no. 2 script liner

CANVAS
One 18 x 24-inch (.46 x .69m) stretched canvas, with 1½-inch (3.8 cm) thick, staple-free edges, by Fredrix Creative Edge

ADDITIONAL SUPPLIES
- Narrow palette knife
- FolkArt HD Clear Medium

ANYONE WHO HAS SPENT TIME in Florida or the southern coastal regions has seen how the amazing sunrise colors light up even the most forested landscapes. In this painting inspired by Florida's Everglades, the water leads your eye to the brightest area of the sky where the sun has just risen, creating a dazzling light and a warmth you can almost feel. One of the natural wonders of such areas are the cypress trees that rise up out of the water, surrounded by their conical "knees" that help the trees' roots breathe. Another distinctive detail is the Spanish moss that drapes the foliage of the trees. This moss is gray or brown, not green, and is easily painted with vertical strokes of a flat brush.

FOLKART HIGH DEFINITION ACRYLIC PAINT

Sunflower	Yellow Ochre	Yellow Light	Wicker White	Burnt Umber
Thicket	Green Forest	Yellow Citron	Brilliant Ultramarine	Licorice

51

Place In the Background

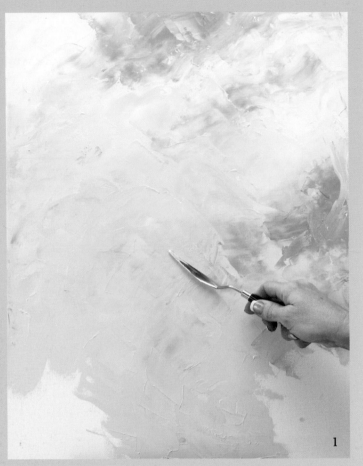

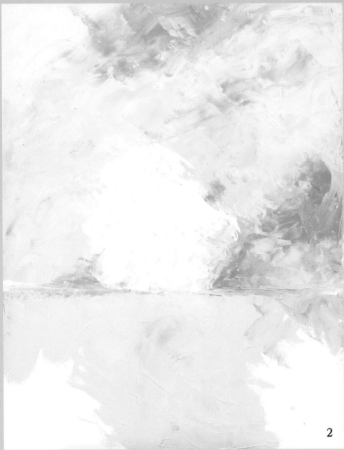

1

2

3

1 Using a narrow palette knife, start placing in the sky with Sunflower, Yellow Ochre and Yellow Light, keeping the Yellow Light in the center for the brightest, sunniest area of the sky, and using the Yellow Ochre for the darker areas. Keep the area well textured; don't smooth it out with the knife.

2 Brighten the center sky area with Wicker White using the palette knife and working wet-into-wet. Use the knife to tap in a subtle guideline for your horizon line. Beef up the darker areas with more Yellow Ochre on the knife.

3 The shadowy background trees are placed in with Burnt Umber on a ¾-inch (19mm) flat. Dress the brush in Clear Medium first before picking up the Burnt Umber. Use the chisel edge of the flat to draw the trunks. To add perspective, as if the trees are leading your eye toward the sunrise, place the shorter trunks in the center, making them taller as they get closer to the sides of the canvas.

Paint the Focal Point

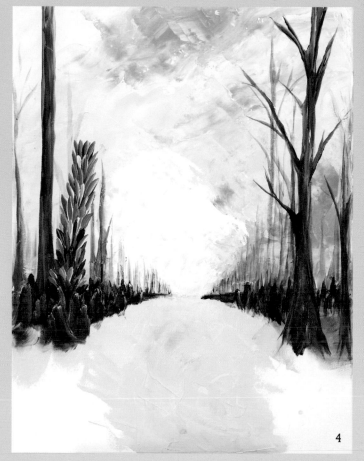

4

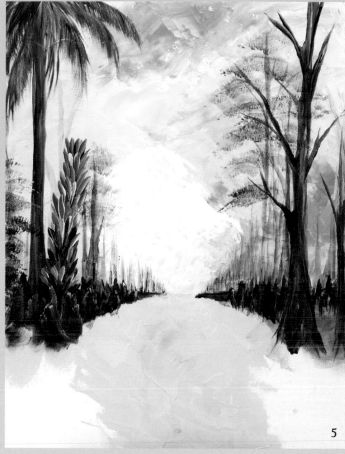

5

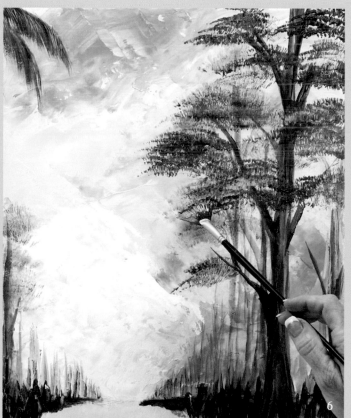

6

4 Double load a ¾-inch (19mm) flat with Burnt Umber and Sunflower and paint the trunks of the main foreground trees. Pick up a little Wicker White on your brush sometimes to vary the colors. The cabbage palm tree on the left has a rough-textured trunk painted with short chisel-edge strokes. Use the same colors to paint the short, conical cypress knees that grow up from the water along the bases of the cypress trees.

5 Load a no. 4 fan brush with Clear Medium and pick up Burnt Umber. Dab in the foliage of the shadow cypress trees in the right background. With the same dirty brush, pick up Thicket, Green Forest and Sunflower and dab on the green foliage of the left-side tree. Stroke in the palm fronds of the tall tree at the far left side, staying up on the tips of the fan brush bristles and stroking curving lines downward.

6 With Yellow Citron and Green Forest on a no. 4 fan, tap on the foliage of the cypress tree on the right. Pick up Thicket sometimes for color variation.

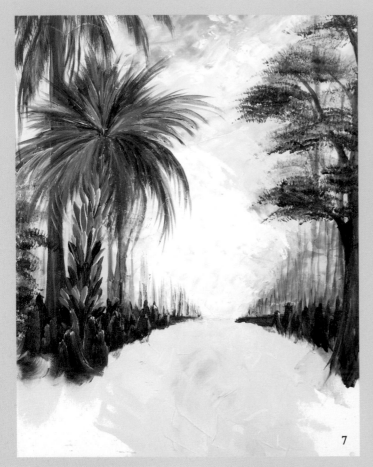

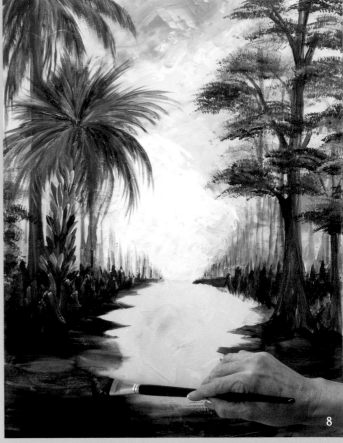

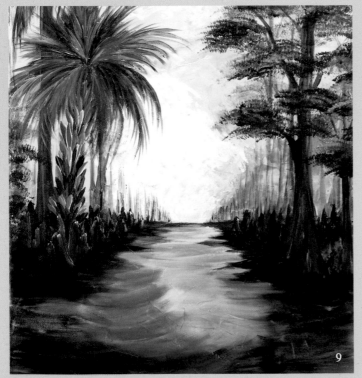

7 Double load a no. 16 flat with Yellow Citron and Green Forest, pick up Thicket sometimes for color variation, and stroke in the fronds of the cabbage palm tree on the left, using the chisel edge. If the paint doesn't cover the trunk of the tall palm behind it, add a little Sunflower to the mix to make the greens more opaque. Highlight along a few of the fronds with Yellow Light on a no. 2 script liner.

8 Double load a 1-inch (25mm) flat with Green Forest and Brilliant Ultramarine. Use lateral strokes to add the green foliage laying in the water at the foreground and along the base of the trees. Stroke inward toward the center from the outside edges.

9 Double load Yellow Light and Sunflower on the flat brush, pick up a touch of Brilliant Ultramarine and work this color into the water area along the sides. Establish the horizon line where the water meets the sky using the same brush. Leave the center of the water yellow to show the reflection of the sun. Deepen the green in the foreground with Green Forest.

Fill In with the Details

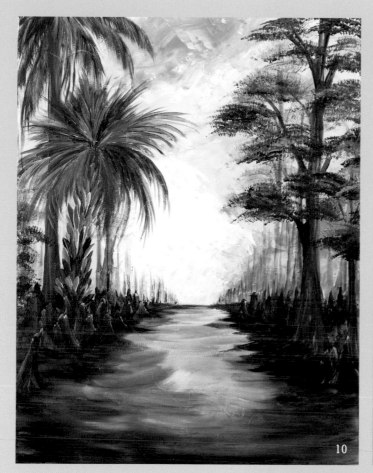

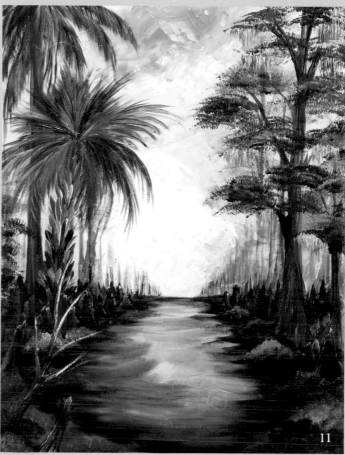

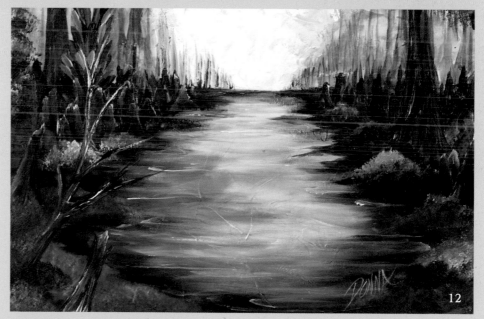

10 Deepen the blue water color with more Brilliant Ultramarine in the foreground. Double load a no. 12 flat with Burnt Umber and Wicker White and paint the foreground cypress knees and the broken tree stump on the left side.

11 Double load Yellow Citron and Green Forest on the scruffy brush and pounce in lighter green foliage along the water's edge where it is highlighted by the sunrise colors. Pick up Wicker White on the brush sometimes for color variation. Load a no. 16 flat with Burnt Umber and paint the bare branches in the foreground at the lower left, highlighting them with Wicker White along one edge.

Add Spanish moss to the cypress branches using Wicker White and Licorice on a no. 12 flat. Start each cluster of gray moss by tapping a short horizontal line on a tree branch, then pulling downward from that line with short choppy strokes to show that the moss is hanging. Highlight some of the moss with Wicker White on a no. 2 script liner.

12 Dress a 1-inch (25mm) brush in Clear Medium and pick up a little Wicker White. Use short, horizontal strokes to indicate little waves and movement in the water in the center and along the edges where it meets the foliage. Keep the pressure on your brush very light; don't press down hard for these strokes.

Mountains of Mojave

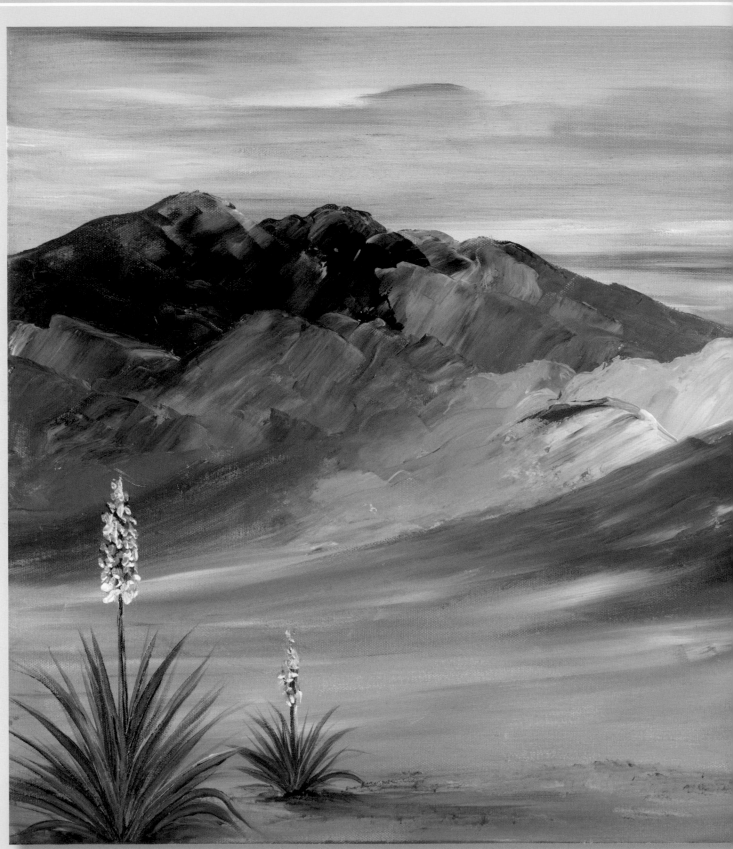

T HESE ANCIENT AND BARREN mountains in the high desert of California were painted using a sponge painter and a wide palette knife to shape the slopes and ridges. I kept the paint thick and textural to express their craggy forms. The green yucca plants add a hint of life.

BRUSHES
- 1-inch (25mm) flat
- no. 10 flat
- no. 2 script liner

CANVAS
One 24 x 18-inch (.69 x .46m) stretched canvas, with 1½-inch (3.8 cm) thick, staple-free edges, by Fredrix Creative Edge

ADDITIONAL SUPPLIES
- Sponge painter
- Wide palette knife
- FolkArt HD Clear Medium

FOLKART HIGH DEFINITION ACRYLIC PAINT

Periwinkle	Wicker White	Butter Pecan
Sunflower	Yellow Light	Engine Red
Violet Pansy	Brilliant Ultramarine	Maple Syrup
Yellow Ochre	Thicket	Burnt Umber
School Bus Yellow		

Place In the Background

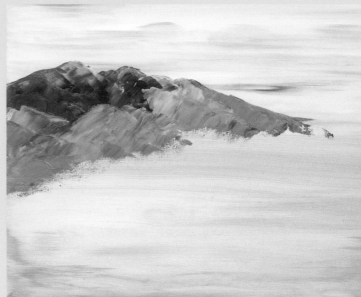

1 Double load Periwinkle and Wicker White on a sponge painter, pick up some Clear Medium and stroke in the sky color using horizontal motions across the canvas. Pick up more Periwinkle sometimes and more Wicker White sometimes to get color variations. For the sandy desert area, dress a sponge painter in medium and pick up Butter Pecan and Sunflower. Add a small area of thinned Yellow Light in the sky to imply sunlight.

2 Block in the most distant purple mountains with Violet Pansy and Brilliant Ultramarine using a sponge to get the basic shape of the ridgeline and to fill in. Switch to a wide palette knife and use the same colors plus some Wicker White to lay in the slanted strata of the rocks. Pick up more blue sometimes and more purple sometimes to indicate layers of rocks and valleys. Switch back to a sponge and add more blue to the sky using lateral motions. Streak in a little bit of Engine Red and Wicker White for sunset colors.

3 With Maple Syrup, Yellow Ochre and a little Engine Red, use your wide palette knife to block in the sand-stone mountains in the mid-ground. Lighten some areas with Butter Pecan and Wicker White to show rock layers, and define some top ridgelines with more Maple Syrup.

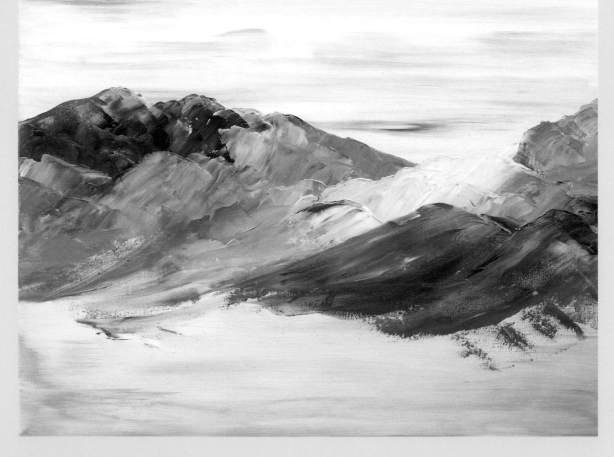

Paint the Focal Point

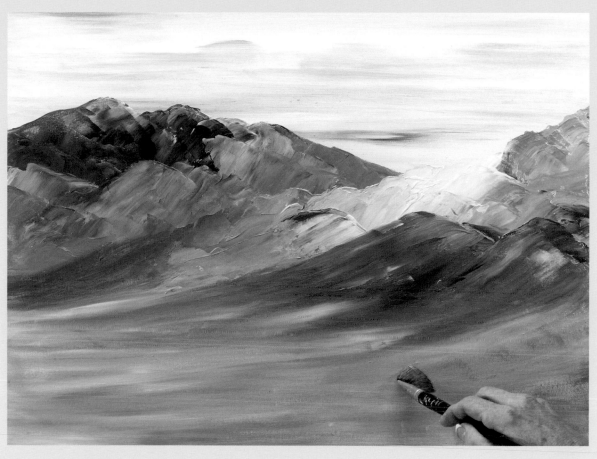

4 Use a 1-inch (25mm) flat brush to soften the mountainsides as they slope to the desert floor. Resist the temptation to overwork the mountains—once they're in and look like this, leave them alone. The roughness of the rocky slopes will be lost if you soften them too much with the brush. Enrich the colors of the sand with some thinned Yellow Ochre and add hints of green vegetation with Thicket and Butter Pecan double loaded on the flat.

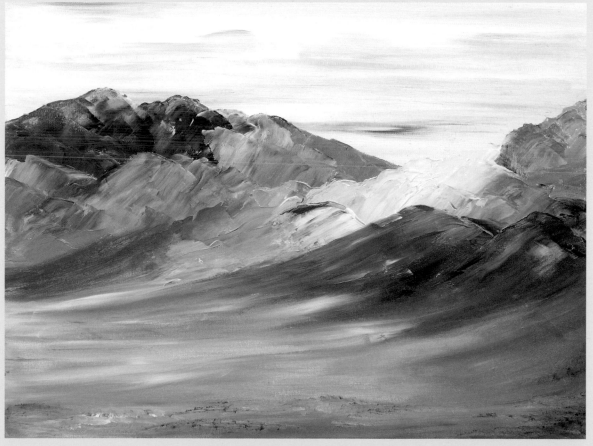

5 Dab in these same colors along the bottom of the canvas to indicate rough rocky ground in the foreground.

Paint the Focal Point

6 Use the chisel edge of a no. 10 flat and Thicket plus a little Sunflower to stroke in the spiky leaves of the yucca plants in the foreground. Start at the base and stroke upward and outward, lifting to the sharp point at the tip of each leaf. When all the leaves are filled in on the smaller yucca plant, shade underneath it with the same colors and brush.

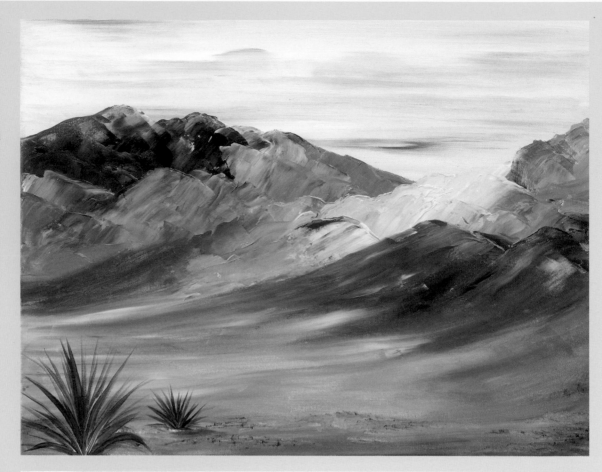

7 With Burnt Umber on a no. 10 flat, paint the tall main stems of the yuccas, then use short angled strokes to pull smaller stems at the top.

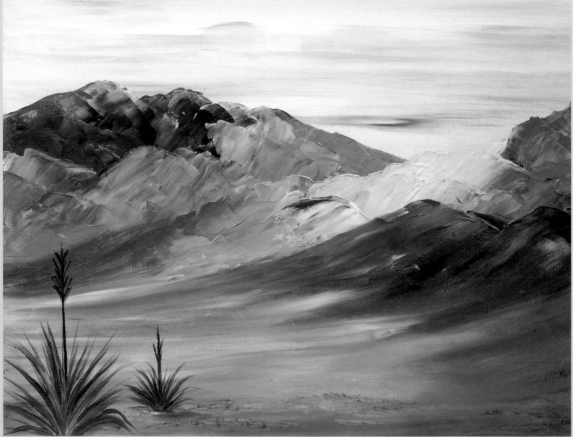

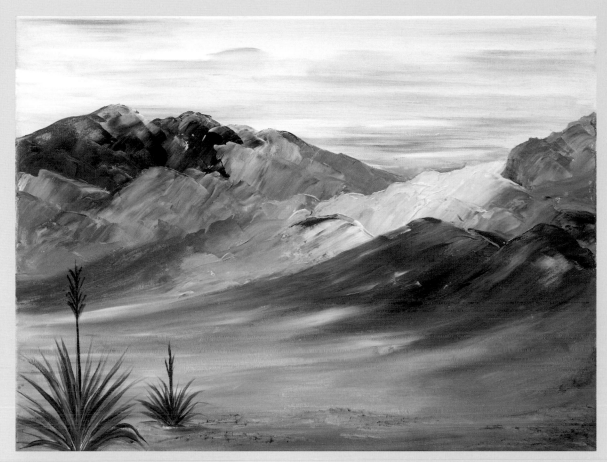

8 Strengthen the sky colors where the sun is setting with Yellow Ochre and a little bit of School Bus Yellow.

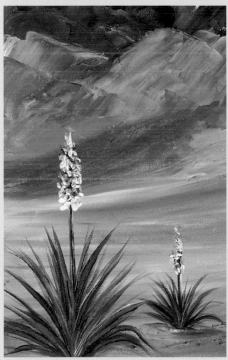

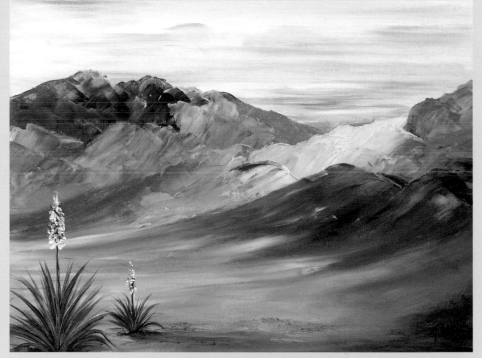

9 Add the yucca plant flowers with thick Wicker White and Yellow Ochre on the tip of a no. 2 script liner.

10 Darken the lower right corner with thinned Burnt Umber and shade under the yucca plants to finish.

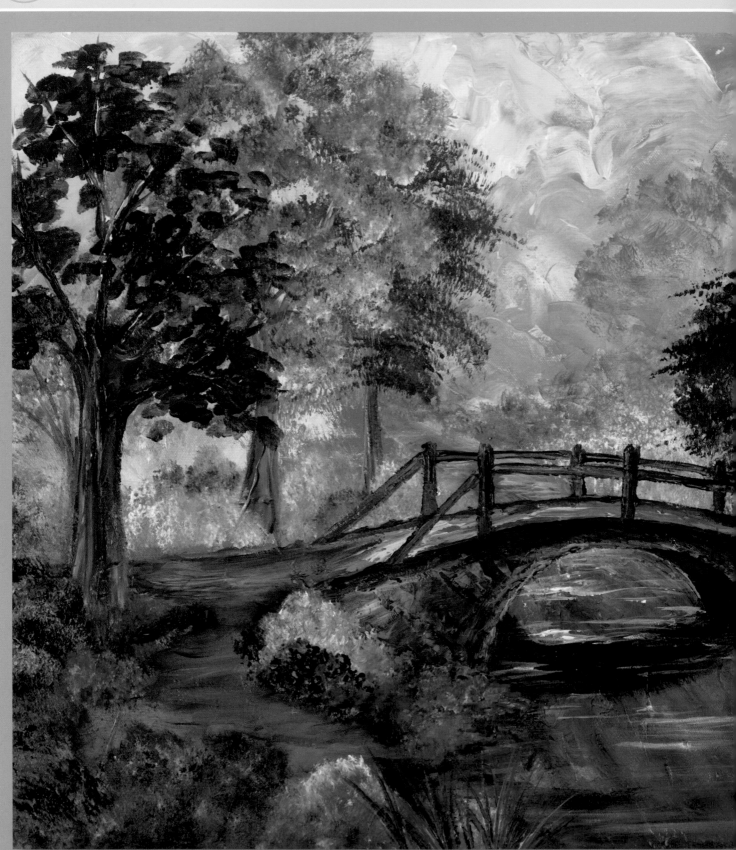

T HIS IS A HIGHLY TEXTURED
PAINTING that shows what you can
achieve by using a palette knife, a fan brush
and a large scruffy. These tools will help you work
quickly to create such diverse textures as flowing water,
old weathered wood, and flowering trees.

BRUSHES
- ¾-inch (19mm) flat
- nos. 10 and 16 flats
- no. 4 fan
- large scruffy
- no. 2 script liner

CANVAS
One 24 x 18-inch
(.69 x .46m) stretched
canvas, with 1½-inch
(3.8 cm) thick, staple-
free edges, by Fredrix
Creative Edge

ADDITIONAL
SUPPLIES
- Wide palette knife
- FolkArt HD Clear
 Medium

FOLKART HIGH DEFINITION
ACRYLIC PAINT

Yellow Light Yellow Ochre Wicker White

Forest Moss Fresh Foliage Periwinkle

 Brilliant
Ultramarine Pure Orange Engine Red

Berry Wine Violet Pansy Yellow Citron

Burnt Umber Butter Pecan Green Forest

Thicket Sunflower

63

Place In the Background

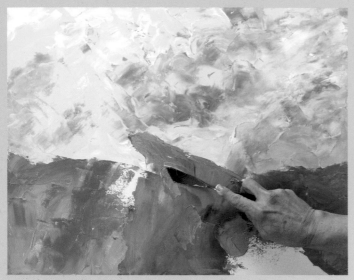

1 To begin the yellow sky area, alternate picking up Yellow Light, Yellow Ochre and Wicker White on a wide palette knife and place in the colors keeping the texture thick and tactile. Next block in the green foliage area alternating Forest Moss and Fresh Foliage, using the wide palette knife. Block in the water with Periwinkle and Brilliant Ultramarine on the wide palette knife. Do not smooth out these areas, leave them very textural.

2 Add misty background trees with Pure Orange, Engine Red and Berry Wine, tapping these colors on lightly with the wide palette knife. The purple trees are Violet Pansy and Wicker White tapped on with a no. 4 fan brush, and the greens are Forest Moss and Yellow Citron pounced on with a scruffy.

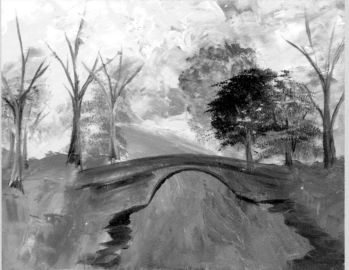

3 With Burnt Umber and Butter Pecan double loaded on a ¾-inch (19mm) flat, draw in the background tree trunks using the chisel edge of the brush, picking up Wicker White occasionally to highlight.

4 Use the same dirty brush to map in the placement of the wooden footbridge that arches over the river. Place the muddy banks of the river in the foreground using the same colors.

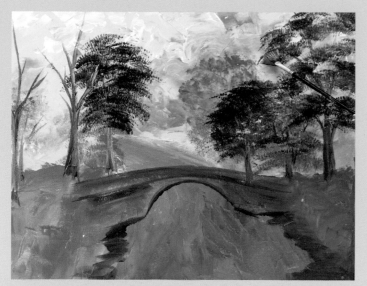

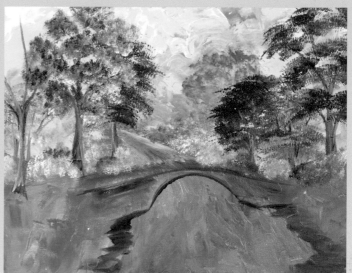

5 With Green Forest and Thicket loaded on a no. 4 fan brush, pick up some Burnt Umber and tap in the airy foliage on the background tree on the left side. Pick up a little Yellow Citron and tap in the foliage on the background tree on the right.

6 Load a scruffy with Thicket and Forest Moss and pounce on the darker layer of foliage on the foreground tree on the left. Pick up Wicker White and highlight parts of the foliage to separate it from the background tree. Pick up Thicket and Wicker White on the scruffy and pounce in the low shrubs around the bases of the trees.

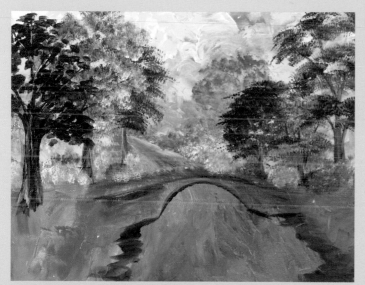

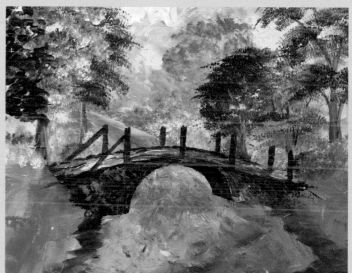

7 For the colorful foreground tree at the left side, load a no. 10 flat with Engine Red and Pure Orange and dab on the leaves. Pick up Berry Wine on the dirty brush and shade the leaves to knock back the brightness of the colors. Darken the trunk and branches with thick Burnt Umber on a no. 16 flat and highlight here and there with Wicker White on a no. 2 script liner.

8 Using the wide palette knife and alternating Burnt Umber, Yellow Ochre and Butter Pecan, texturize the wooden planks and supports of the footbridge. Use Burnt Umber to darken and shade the underside of the arch. Load the no. 16 flat brush with Butter Pecan and smooth out the pathway over the top of the bridge, highlighting the path with spots of Sunflower. Dab in Burnt Umber edges along both sides of the pathway on the bridge, then smooth out and shape them with the flat brush. Use the chisel edge of the brush to draw in the posts of the handrail.

Paint the Focal Point

9 With Burnt Umber on a large flat brush, pull the riverbanks inward to narrow the width of the river itself as it flows toward you from under the bridge. Add a dirt pathway coming down to the riverbank on the left. Double load Green Forest and Fresh Foliage on the scruffy and pounce in more foliage at the bases of the bridge supports and behind the foreground tree trunks. Also pounce in some foliage along the riverbanks, and add some dark green foliage at the far left side.

10 Highlight the foliage with Yellow Light and Wicker White pounced on with the scruffy. Pick up Violet Pansy and Wicker White on the scruffy and dot in some light purple flowers in the lower right corner of the canvas. Pick up Brilliant Ultramarine on the dirty brush and dot in dark purple flowers in the lower left corner. Dot in some very dark red flowers along the path down to the riverbank.

11 With Burnt Umber and Yellow Ochre double loaded on a no. 16 flat, draw the horizontal railings of the wooden bridge, using the chisel edge of the brush. Load the no. 4 fan with Wicker White and pick up some Yellow Ochre. Tap on the white blossoms of the small flowering tree on the right side. With Brilliant Ultramarine on the ¾-inch (19mm) flat, add a cast shadow on the water under the arched bridge. Notice that the shadow curves in the opposite direction as the arch of the bridge. The arch and the shadow together create an oval shape.

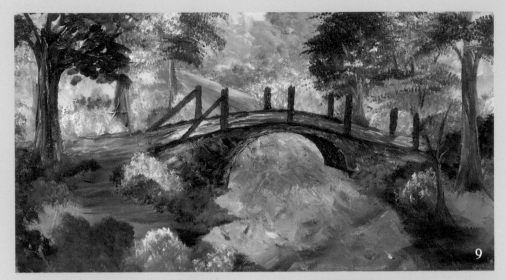

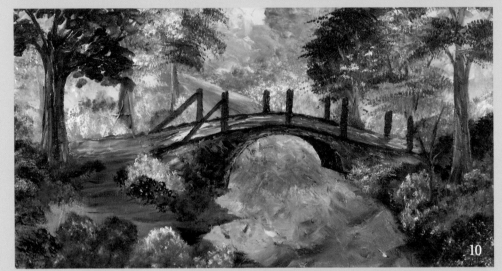

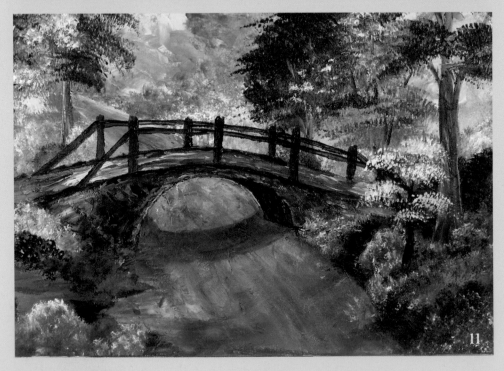

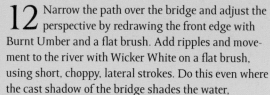

Fill In with the Details

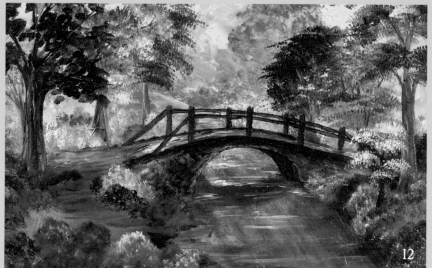

12 Narrow the path over the bridge and adjust the perspective by redrawing the front edge with Burnt Umber and a flat brush. Add ripples and movement to the river with Wicker White on a flat brush, using short, choppy, lateral strokes. Do this even where the cast shadow of the bridge shades the water,

13 Load a ¾-inch (19mm) flat with Clear Medium and sideload into Burnt Umber. Float shading along the edges of the pathways leading up to the bridge and down to the riverbank on the left. Highlight the top sides of the wooden railings with Yellow Ochre.

14 Finish with spiky reeds and grasses in the near foreground along the riverbank, using Green Forest and Yellow Light double loaded on a no. 10 flat.

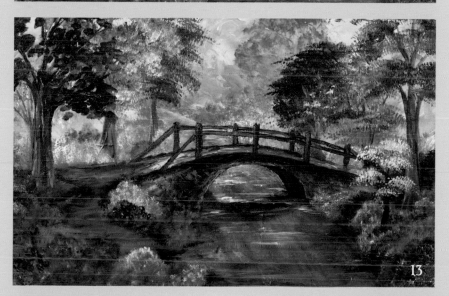

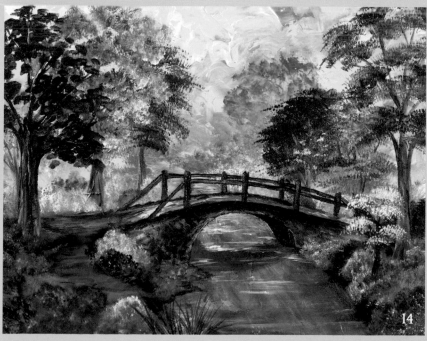

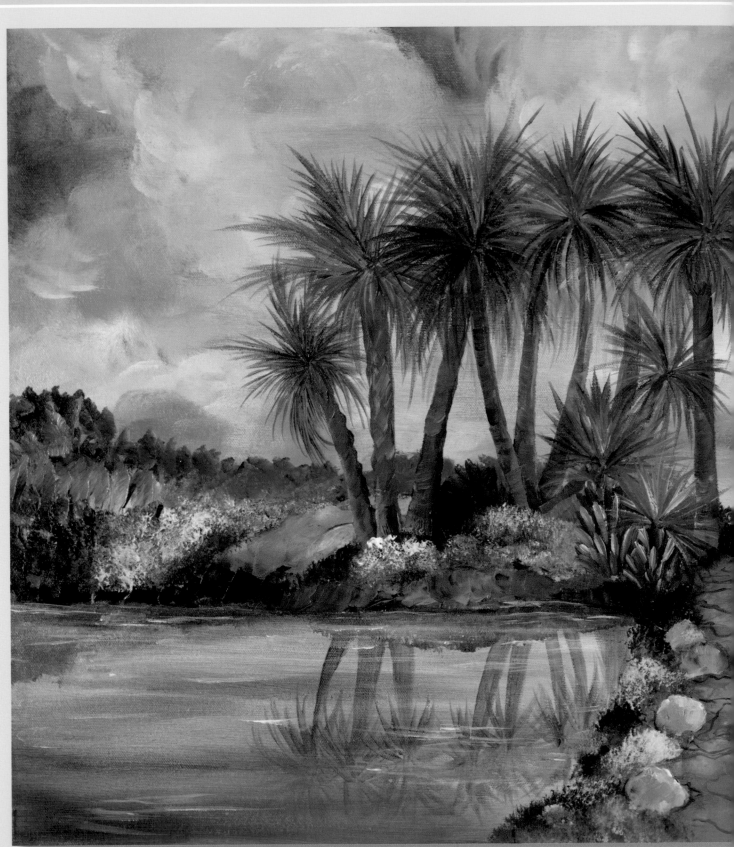

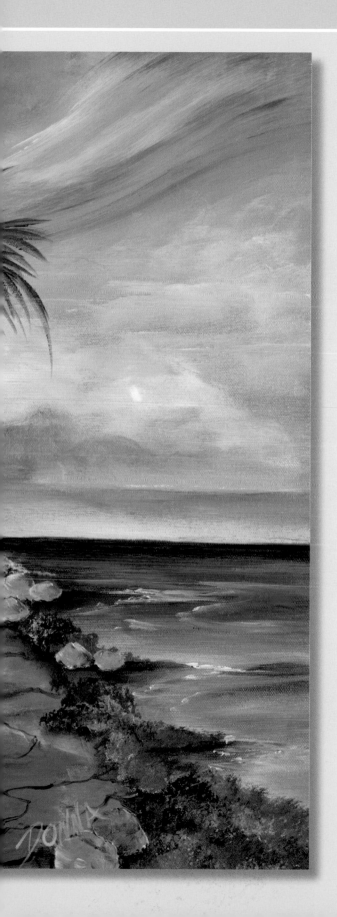

H
AVE YOU EVER DAYDREAMED about a nice, relaxing vacation on a warm tropical island? If that isn't possible, how about painting it instead? Palm trees are easy and fun to paint, and the brightly colored flowers are just pounced on with a scruffy brush. Even painting can be relaxing!

BRUSHES
- ¾-inch (19mm) flat
- 1-inch (25mm) flat
- nos. 10 and 12 flats
- large scruffy
- no. 2 script liner

CANVAS
One 24 x 18-inch (.69 x .46m) stretched canvas, with 1½-inch (3.8 cm) thick, staple-free edges, by Fredrix Creative Edge

ADDITIONAL SUPPLIES
- FolkArt Sponge Painters
- FolkArt HD Clear Medium

FOLKART HIGH DEFINITION ACRYLIC PAINT

Periwinkle

Wicker White

Calypso Sky

Brilliant Ultramarine

Yellow Light

Butter Pecan

Yellow Ochre

Maple Syrup

Green Forest

Burnt Umber

Yellow Citron

Engine Red

Sponge On the Background

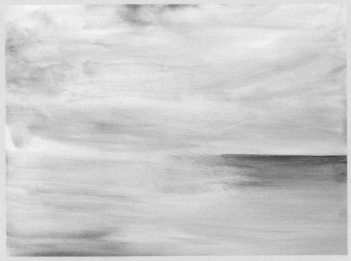

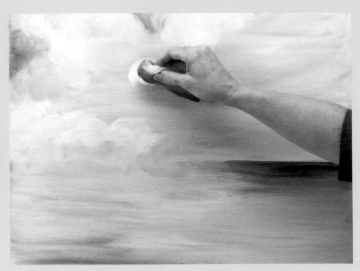

1 Load Periwinkle and Wicker White on a sponge painter, pick up some Clear Medium and stroke in the sky color using horizontal motions across the canvas. Alternate this color with Calypso Sky and Brilliant Ultramarine as you sponge in the sky. Carry these background colors all the way to the bottom of the canvas. Establish the horizon line of the ocean with Brilliant Ultramarine coming in from the right side of the canvas.

2 Pick up more Wicker White on your dirty sponge and begin placing in the puffy clouds. Use circular motions to get the basic shape, then use the flat of your sponge and lateral motions to soften the clouds and blend out their edges.

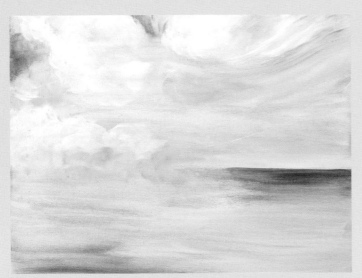

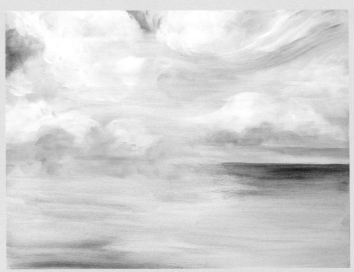

3 Among the puffy clouds are streaks of cirrus clouds. Load a sponge with medium, Brilliant Ultramarine and Wicker White and stroke in the wispy cirrus clouds with curving strokes coming down from the top right toward the center. Pick up a tiny amount of Yellow Light to indicate sun reflections.

4 Use a ¾-inch (19mm) flat and Yellow Light and work this color into the sky just above the horizon. Above this, place some more puffy white clouds and darken their bottoms with thinned Ultramarine Blue. At the left side, add Calypso Sky into the sky area.

Paint the Focal Point

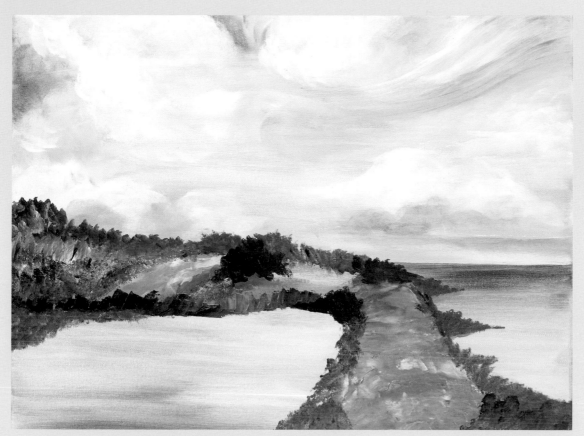

5 Start by blocking in the sand bar using Butter Pecan and Wicker White. For color variation, alternate picking up Yellow Ochre and Maple Syrup. Use the 1-inch (25mm) flat to block in the basic shape, then fill in the colors with the wide palette knife to get texture. Shade along the curve of the inlet with Maple Syrup.

With Green Forest and Burnt Umber on a 1-inch (25mm) flat, tap in the background foliage along the top and outside edges of the sand bar. Pick up Butter Pecan sometimes and Yellow Citron here and there to lighten and warm up the foliage color.

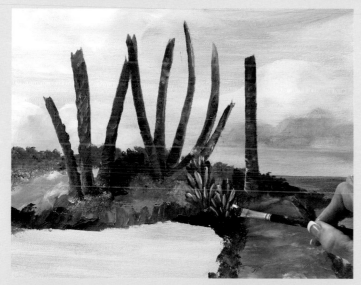

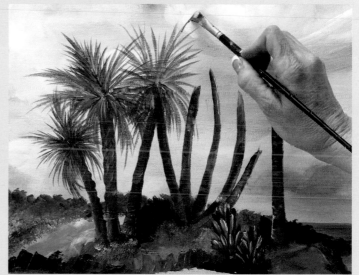

6 Load a no. 10 flat with Burnt Umber and draw in the basic lines of the tall palm tree trunks. Pick up Yellow Ochre on the dirty brush and widen and fill out each trunk, stroking upward from the base. Stroke across the trunks to indicate growth segments by adding some Butter Pecan to the Burnt Umber, alternating with Wicker White.

Tap in foliage at the base of the palm trunks with Green Forest and Yellow Citron using the scruffy brush. Load the no. 10 flat with Burnt Umber and Wicker White and paint the trunk segments of the short cabbage palms in front.

7 To paint the foliage on the tall palm trees, start with the background trees. Load a no. 10 flat with Green Forest and more Yellow Citron and use the chisel edge of the brush to draw each palm frond outward from the center with light curving strokes. Use little pressure and stay up on the chisel edge so that each frond is very narrow.

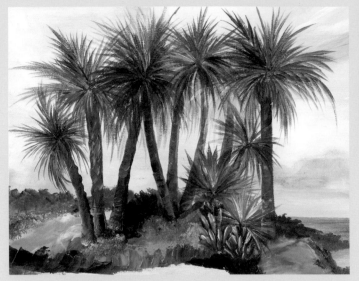

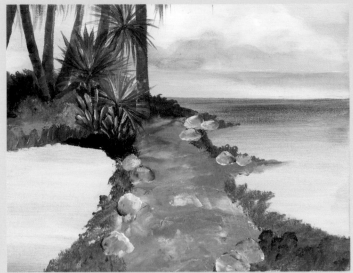

8 For the tall palms in front of the ones you just painted, pick up more Green Forest to darken and enrich the color of these fronds. Occasionally pick up Wicker White to highlight a few fronds here and there. For the tall palm at the right, pick up Butter Pecan on your dirty brush and paint some dried, brown fronds. The two short cabbage palms are painted with the same colors, but pick up more Wicker White to lighten these fan-shaped fronds.

9 The coquina rocks (which are broken shells and corals that have become cemented together into a mass) along the sandbar are painted with a no. 12 flat and Butter Pecan plus Wicker White. Shape them with some Yellow Ochre for the lighter sides and Burnt Umber to shade and separate them. Highlight the tops of the rocks with Wicker White.

10 Begin the mounds of flowers with the green foliage, using the scruffy brush loaded with Thicket, Green Forest and highlighting occasionally with Yellow Light. Pounce in the wild daisies with Yellow Light and Wicker White on the scruffy. The pink flowers are Engine Red and Wicker White pounced in with the scruffy.

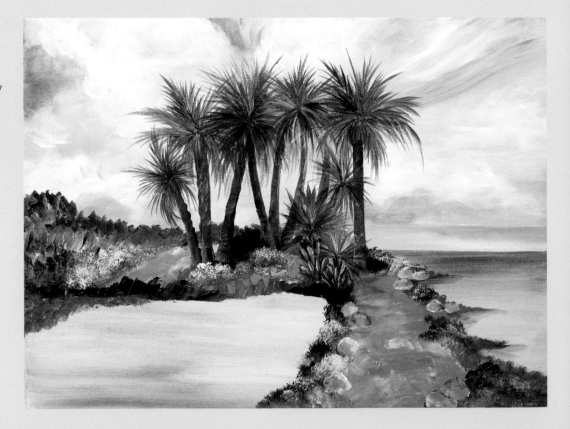

Fill In with the Details

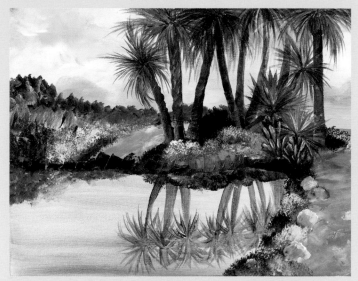

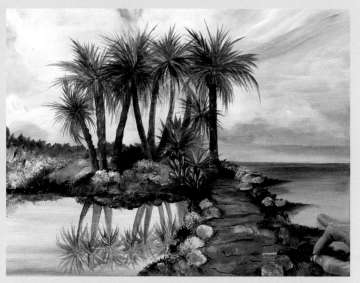

11 Start the reflections in the inlet water by painting the palm trees and the foliage under the palms, using the same colors you used in steps 6, 7 and 8, but thinned with medium. Let that area dry completely and meanwhile go on to the next step.

12 To detail the sandbar, load the ¾-inch (19mm) flat with medium and sideload into Yellow Ochre. Stroke and blend this color into the sandbar. Shade the sandbar with thinned Burnt Umber to indicate dips and low places. Use the same brush to pull areas of the sandbar out to the right and slant down to the water. Indicate cracks in the ground of the sandbar using a no. 2 script liner and inky Burnt Umber thinned with water. Use the same inky Burnt Umber and a flat brush to shade under and around the coquina rocks.

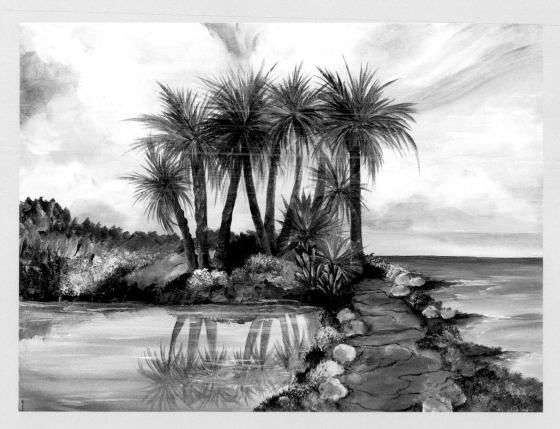

13 Load a 1-inch (25mm) flat with medium and Brilliant Ultramarine and shade the inlet where the water meets the ground. Streak this color using horizontal strokes into the inlet water to deepen the blue. Take a clean flat brush and pick up medium and Wicker White and haze over the inlet water to knock back and soften the reflections of the palm trees and foliage. Use the chisel edge of the same brush and short lateral strokes to indicate little waves and water movement.

In the open ocean at the right, pick up more medium on a ¾-inch (19mm) flat and load with Brilliant Ultramarine and Calypso Sky. Enrich and deepen the water color, using more Calypso Sky nearer the shore to indicate shallow water. Pick up medium and Wicker White on a flat and use the chisel edge to draw white foamy waves coming ashore.

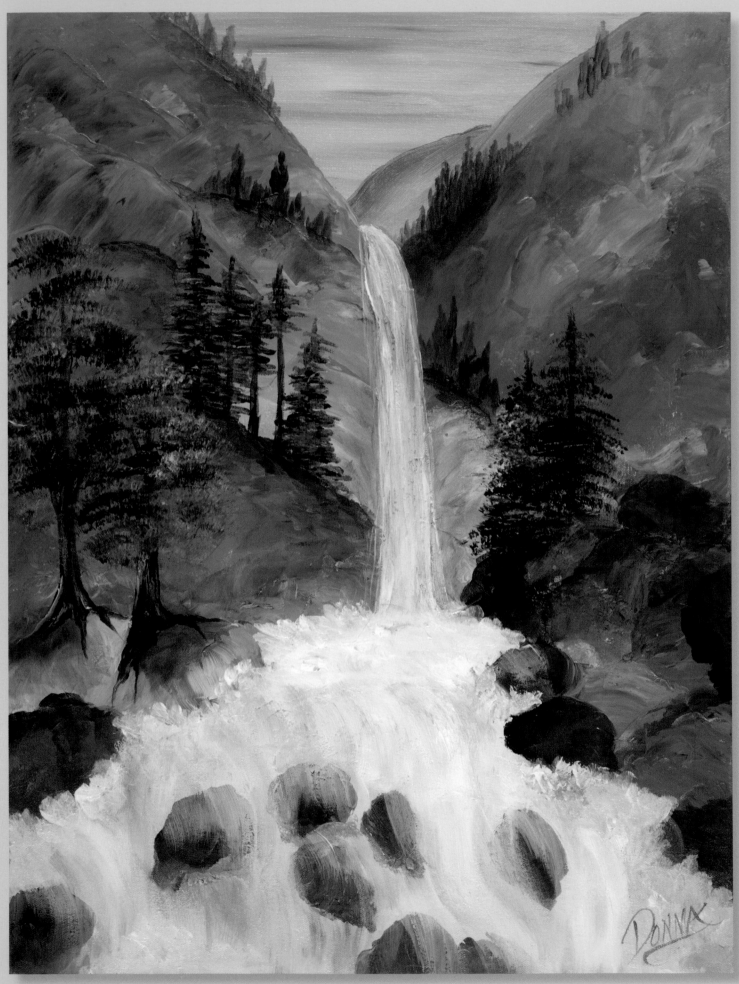

74

Yellowstone Falls

BRUSHES
- ¾-inch (19mm) flat
- 1-inch (25mm) flat
- nos. 10 and 16 flats
- no. 4 fan
- no. 2 script liner

CANVAS
One 18 x 24-inch (.46 x .69m) stretched canvas, with 1½-inch (3.8 cm) thick, staple-free edges, by Fredrix Creative Edge

ADDITIONAL SUPPLIES
- FolkArt Sponge Painters
- Wide palette knife
- FolkArt HD Clear Medium

CAPTURING WATER IN MOTION is not as difficult as you might think. When you are painting waterfalls, cascades, foamy pools, waves and whitewater, always keep in mind that water itself is transparent, not opaque. Therefore, your paint should not be opaque. When water is moving over rocks or boulders, or falling steeply from a cliff, you can still see the rocks through the water. To capture this translucency in a painting, don't layer or overstroke the water too much. This landscape is my own interpretation of Yellowstone Falls. I took many artistic liberties with the surroundings to make the painting I wanted. You can do the same—just let your creativity guide you!

FOLKART HIGH DEFINITION ACRYLIC PAINT

Brilliant Ultramarine | Wicker White | Butter Pecan | Maple Syrup | Yellow Ochre

Pure Orange | Sunflower | Burnt Umber | Green Forest | Yellow Citron

Place In the Background

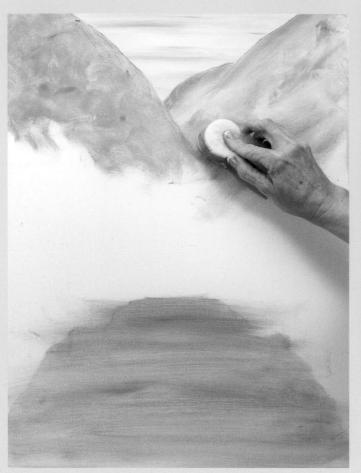

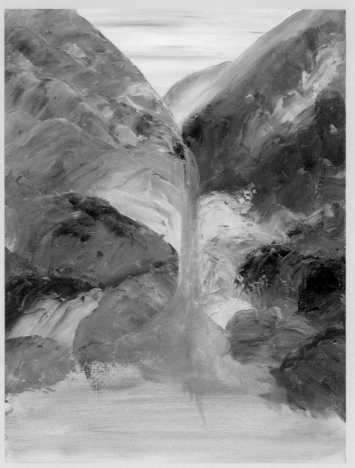

1 With Brilliant Ultramarine and Wicker White on a sponge painter, use horizontal strokes of the sponge to block in the sky and the mountainsides in the background. Pick up a little Butter Pecan and work it into the sky. The grays of the mountainsides are the three sky colors you just used. Place in the cascading water area with the sponge and the same colors.

2 The varying colors of the cliffsides are placed in with the wide palette knife. Start with Butter Pecan and Maple Syrup, picking up Wicker White every so often and occasionally some Brilliant Ultramarine. The warmer sandstone colors on the cliffsides are Yellow Ochre, Maple Syrup, Pure Orange and Sunflower. Use these different warm and cool colors to shape the rocks and edges of the cliffs on both sides of the waterfall, using the wide palette knife to texture the rocks, as if you were icing a cake. If your paint starts to feel dry or stiff, pick up Clear Medium on your painting knife when you pick up paint. Use a dry, ¾-inch (19mm) flat brush to indicate the rough placement of the waterfall and cascades with long vertical strokes, working the wet paint but not adding any more to your brush.

Paint the Focal Point

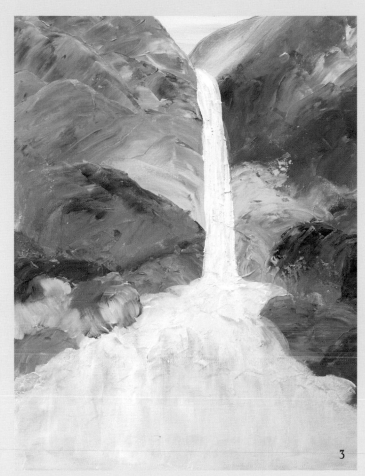

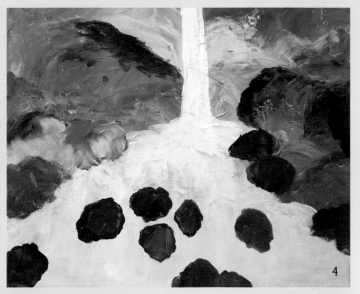

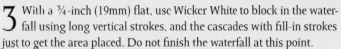

3 With a ¾-inch (19mm) flat, use Wicker White to block in the water-fall using long vertical strokes, and the cascades with fill-in strokes just to get the area placed. Do not finish the waterfall at this point.

4 Add boulders and large and small rock shapes along the sides of the cascades and in among the water, using Burnt Umber, Brilliant Ultramarine, and a little Yellow Ochre. Block in their rough shape with these colors. Later, the mist of the water will set them back and make them appear as if the water is cascading over them.

5 While the rocks are drying, use a no. 10 flat double-loaded with Thicket and Burnt Umber to stroke in the most distant trees on the cliffsides, using short choppy vertical strokes to imply tall skinny ever-greens. Pick up Burnt Umber on the dirty brush and draw in the tree trunks for the fir trees in the midground and the deciduous trees in the foreground. The roots of these trees cling to the shapes of the boulders they're sitting on.

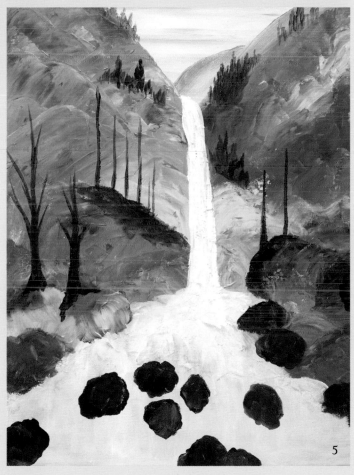

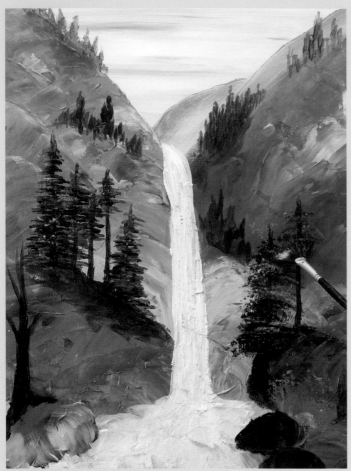

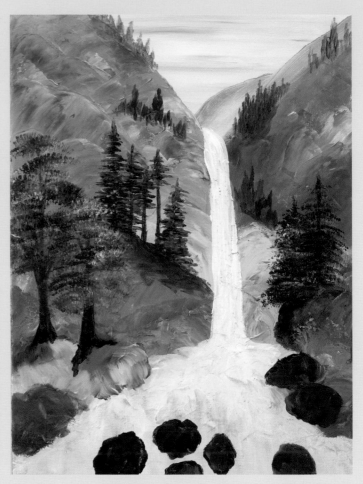

6 With a no. 16 flat, alternate picking up Thicket, Green Forest and Yellow Citron on the brush and dab on the foliage of the evergreen trees on the left midground. Leave parts of the lower trunks bare. Use a no. 4 fan brush to dab in the foliage of the evergreens on the right side of the falls.

7 With the same no. 4 fan brush, use the same three greens to dab in the foliage of the deciduous trees on the left foreground.

Fill In with the Details

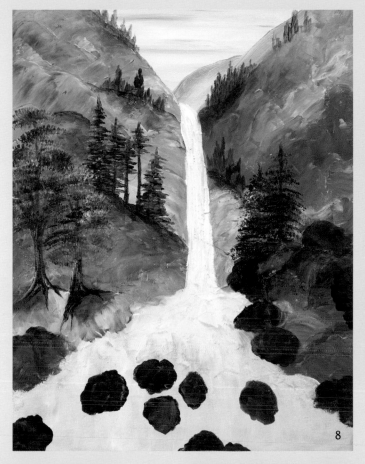

8

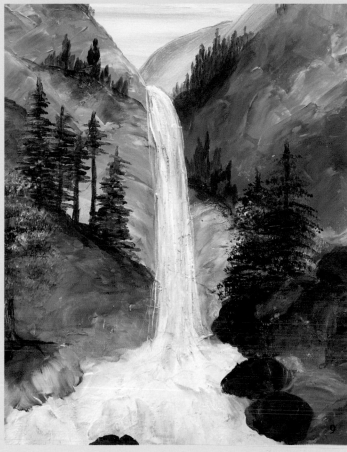

9

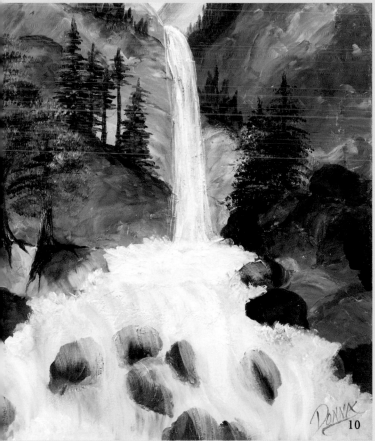

10

8 Double load a no. 2 script liner with Burnt Umber and Wicker White and detail the tree trunks and roots of the deciduous trees at left. Shade the rocks around the tree roots with Burnt Umber and Sunflower. Add some rusty orange color to the rocks on the right, and tone down the yellow of the cliffs next to the falls.

9 Tone and shadow the vertical falls with blue and gray thinned with medium to produce very translucent colors. Use the chisel edge of a flat brush and long vertical strokes to indicate the movement of falling water.

10 To create foam and mist in the cascades area, load a 1-inch (25mm) flat with Wicker White thinned with medium and stroke in the direction of the moving water. Pick up a tiny amount of Burnt Umber on the brush and shade the whitewater under and around the boulders. Pull your flat brush lightly over the rocks to indicate the whitewater flowing over them. Dab white along the sides where the foam hits the rocks.

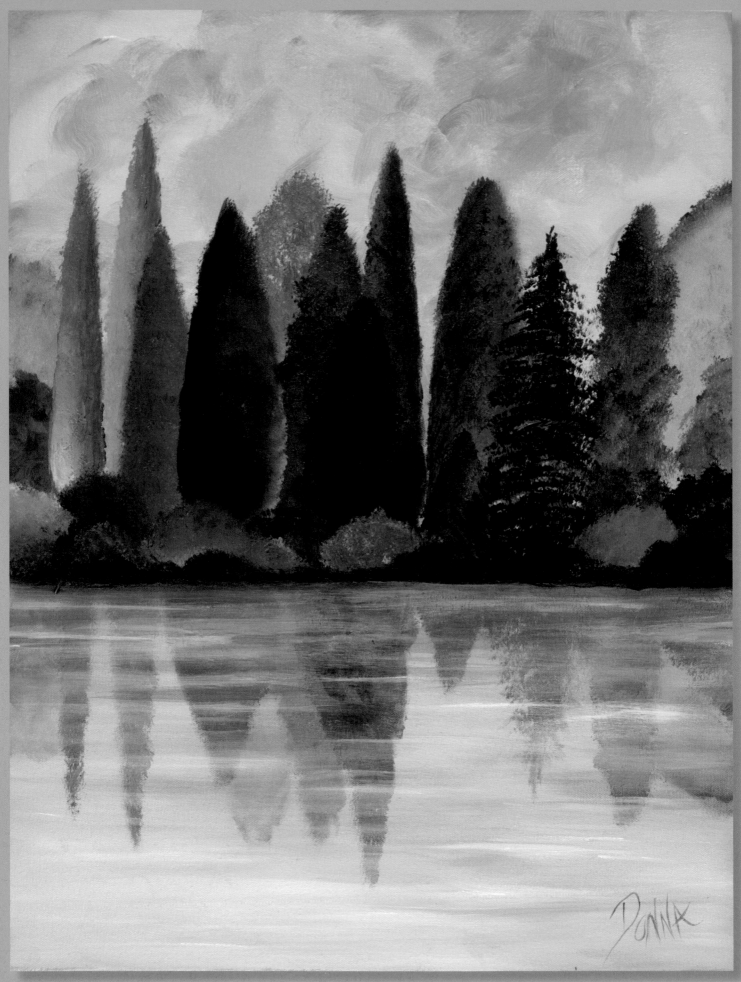

8

Golden Reflections

BRUSHES
- large scruffy
- no. 4 fan
- ¾-inch (19mm) flat

CANVAS
One 18 x 24-inch (.46 x .69m) stretched canvas, with 1½-inch (3.8 cm) thick, staple-free edges, by Fredrix Creative Edge

ADDITIONAL SUPPLIES
- FolkArt Sponge Painters
- FolkArt HD Clear Medium

T'S NOT ALWAYS THE SUBJECT MATTER that attracts your eye to a painting. Often it is the palette of colors or the unusual tools the artist used that create a whole new look to an ordinary scene. When I was thinking about this painting, I asked myself, "Does the sky in a landscape always have to be blue?" "Do the trees always have to be green?" I took a leap of faith and when I finished, the golden-yellow sky contrasting with the red, green and purple trees made a much more interesting painting to my mind. And it was fun to do! I used mostly the sponge for the sky and the scruffy brush for the trees and I was done in less than an hour.

FOLKART HIGH DEFINITION ACRYLIC PAINT

Yellow Ochre	Maple Syrup	Engine Red	Sunflower	Wicker White
Burnt Umber	Thicket	Berry Wine	Night Sky	Green Forest

Sponge On the Background

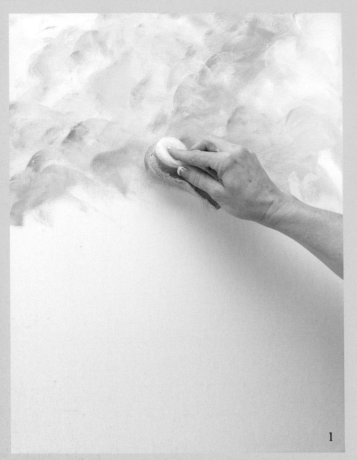

1

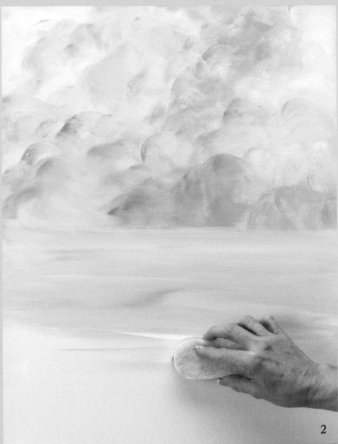

2

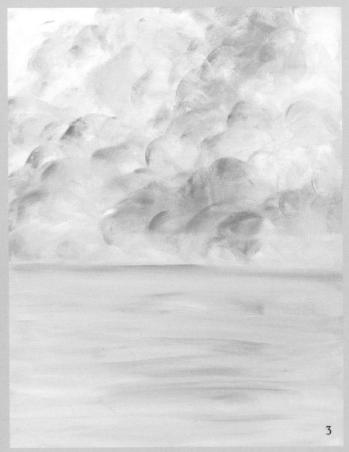

3

1 Begin by sponging on the background sky area. Remember to pick up Clear Medium each time you pick up paint on your sponge. Start with Yellow Ochre and Maple Syrup on the sponge, then pick up a little Engine Red, mottling the texture as you go.

2 Pick up Clear Medium on the sponge, then Sunflower, a little Yellow Ochre and Wicker White, and stroke the water with lateral motions of the sponge.

3 Carry the background over the entire canvas and around the sides, top and bottom.

Paint the Focal Point

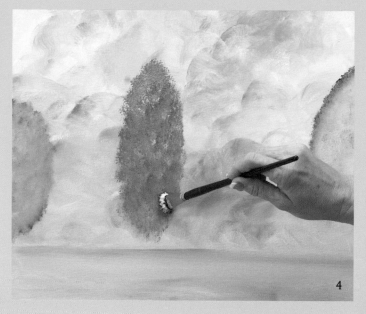

4

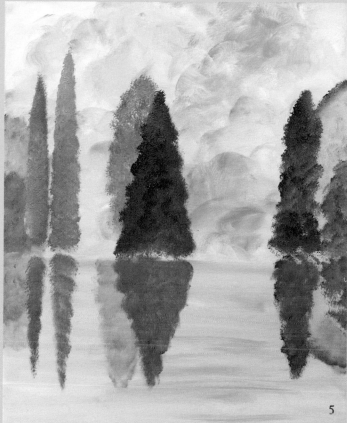

5

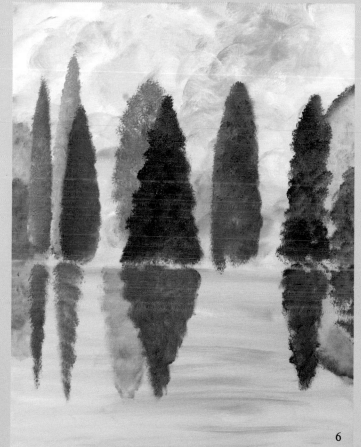

6

4 Start with the background trees. Load Burnt Umber, Sunflower and a touch of Wicker White on the large scruffy brush. Pounce on the two trees at the far right and far left, keeping the Burnt Umber side of the brush to the outside to define the outer edges of the foliage. For the center background tree, load Engine Red, Maple Syrup and Sunflower on the scruffy and pounce on a tall, oval tree shape. (Note: Don't clean out your scruffy between tree colors. Just keep picking up new colors on your dirty brush—that's what gives nice variety to the treeline.)

5 Place the foreground trees starting at the right and left sides. Pounce on the shorter one at the far right with Burnt Umber and Yellow Ochre on the scruffy brush, then pounce on the two tall, skinny trees at the left. With the same dirty brush pick up more Burnt Umber and pounce on two darker brown tree shapes in the center and at right, overlapping the background trees somewhat. Paint the reflection of each tree in the water at the same time, picking up more Clear Medium to thin out the paint and lighten and soften the reflections.

6 The two green fir trees are pounced on with Thicket and a little Sunflower on a scruffy.

Paint the Focal Point

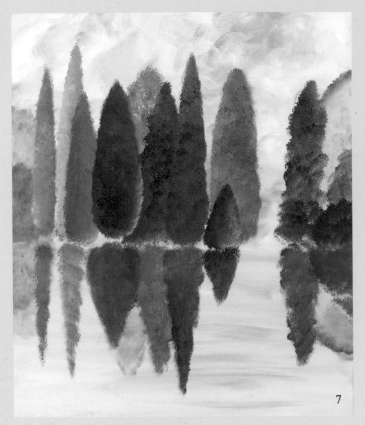

7

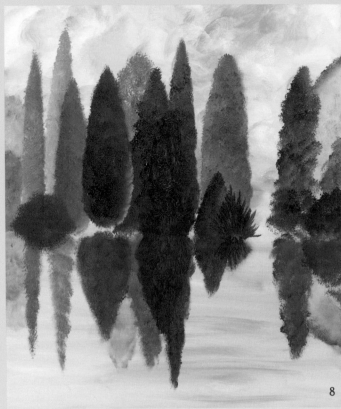

8

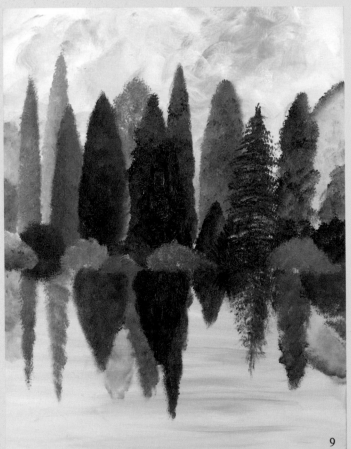

9

7 Load the dirty brush into Berry Wine and add the dark red trees and the shorter trees at the right. Load more Engine Red in your dirty brush and pick up Maple Syrup to paint the tall red tree in the center. Add the reflections as you go with the same colors thinned with Clear Medium.

8 Load Burnt Umber and a little Night Sky on the scruffy to paint the darkest tree in the center. Instead of pouncing the scruffy, stroke the scruffy with downward strokes to get a different texture. Add a short evergreen tree here and there using the chisel edge of a flat brush to get spiky branches. Don't forget to add their reflections in the water too.

9 With Green Forest, Thicket and a little Burnt Umber loaded on a no. 4 fan, tap in the branches of the main evergreen, then add the reflection in the water. Go back to the scruffy and pounce in the low shrubs in the foreground, using a variety of the same colors you used earlier for the trees.

Fill In with the Details

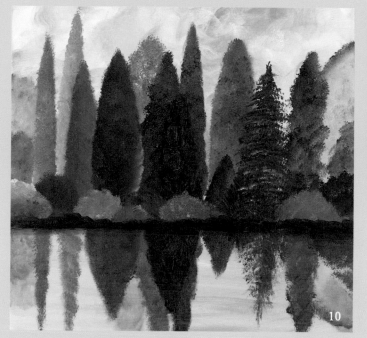

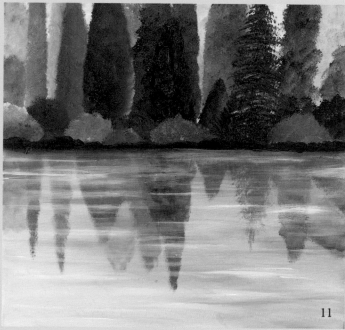

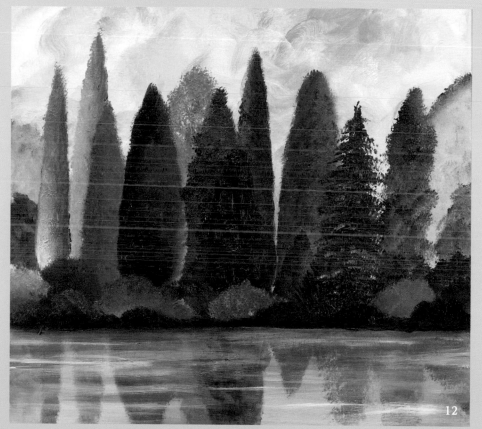

10 Dress a ¾-inch (19mm) flat with medium, pick up Burnt Umber and stroke in the muddy banks of the river's edge. Pick up a little more medium on the brush and soften the line of the riverbank where it meets the water.

11 Load Sunflower and Yellow Ochre and lots of medium on the sponge and use only lateral strokes to soften the reflections in the water and to knock back the colors. The white streaks that show water movement are done with the chisel edge of the ¾-inch (19mm) flat, using Wicker White and lots of medium. Pick up Sunflower sometimes for these streaks, especially nearer the riverbank in the distance where the water is shaded.

12 Add the final details and texture in the trees. Shade along the sides and underneath the trees using darker hues of the original tree colors to separate the trees from each other and to separate the foreground trees from the background trees. Use Burnt Umber with your colors for the darkest shadows.

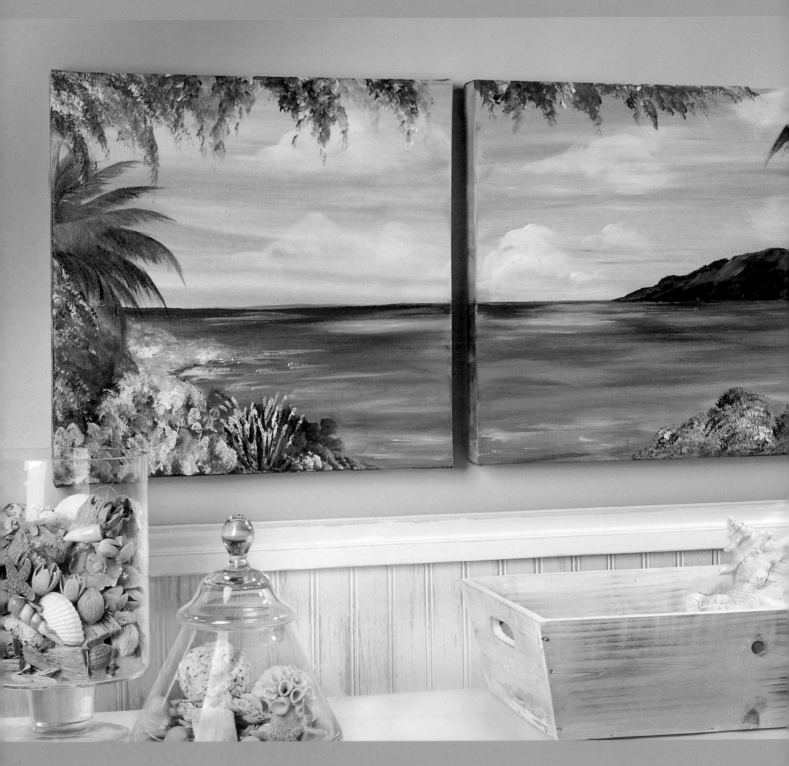

Painting on Multiple Canvases

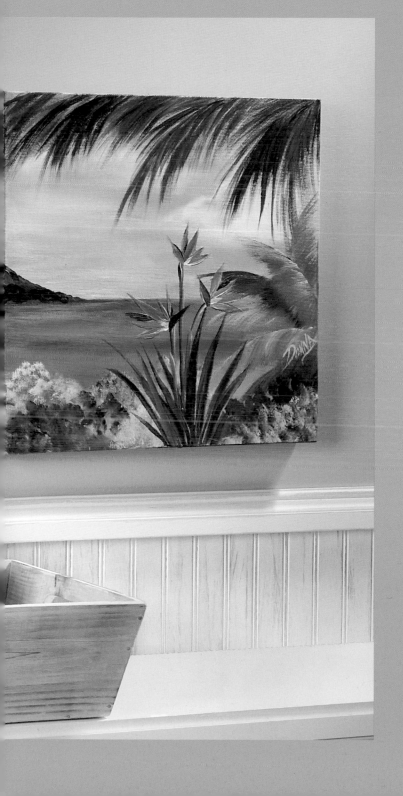

LANDSCAPE PAINTING lends itself especially well to expansive designs that cover two, three, and even four canvases! Depending on the size and shape of the canvases you choose, there are many ways to arrange them to make a bold statement and an impressive display. Two 18 x 24-inch (.46m x .69m) canvases can be placed side-by-side and turned vertically for a large area, or horizontally for a wide area, such as over a sofa. Three 16-inch (.34m) square canvases placed side-by-side horizontally are great for panoramic scenes of the ocean and would look wonderful over a fireplace mantelpiece. Four of the square canvases arranged in a large square will give a fresh and contemporary look to any home decor. Framing is not needed for any of these display ideas—the canvases have finished edges onto which you can continue the painting, giving your artwork "gallery" style.

In this section you'll find seven projects painted on two, three or four canvases and step-by-step instructions for painting a variety of landscapes and scenic panoramas. You'll enjoy the freedom and space and soon you'll be painting like a master!

9 Harvest Hills

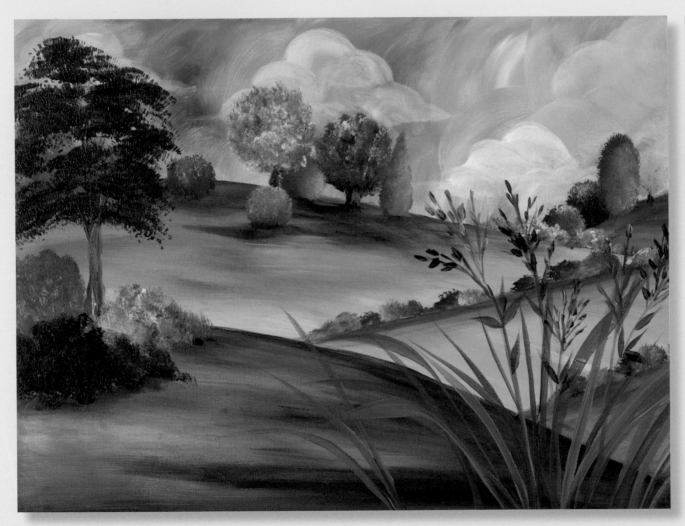

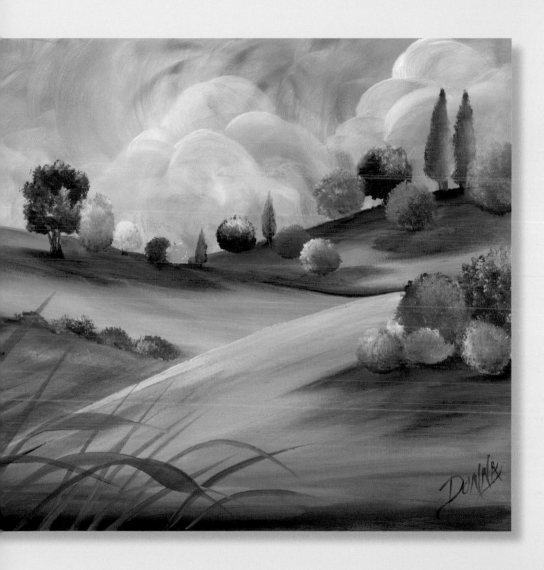

T HIS SCENE

of rolling farm-
lands in autumn
is perfect for painting on
two side-by-side canvases.
The extreme width gives
a feeling of vastness to the
landscape and the curv-
ing shapes remind me of a
country quilt.

BRUSHES
• 1-inch (25mm) flat
• no. 10 flat
• large scruffy
• no. 4 fan

CANVASES
Two 24 x 18-inch (.69 x .46m)
stretched canvases, with 1½-
inch (3.8 cm) thick, staple-free
edges, by Fredrix Creative Edge

ADDITIONAL
SUPPLIES
• FolkArt Sponge Painters
• FolkArt HD Clear Medium

Sponge On the Background

FOLKART HIGH DEFINITION ACRYLIC PAINT

Brilliant Ultramarine | Wicker White | Yellow Ochre | Maple Syrup | Autumn Leaves | Burnt Umber | Sunflower | Berry Wine

Thicket | Engine Red | Yellow Light | Green Forest | Fresh Foliage | Yellow Citron | Forest Moss

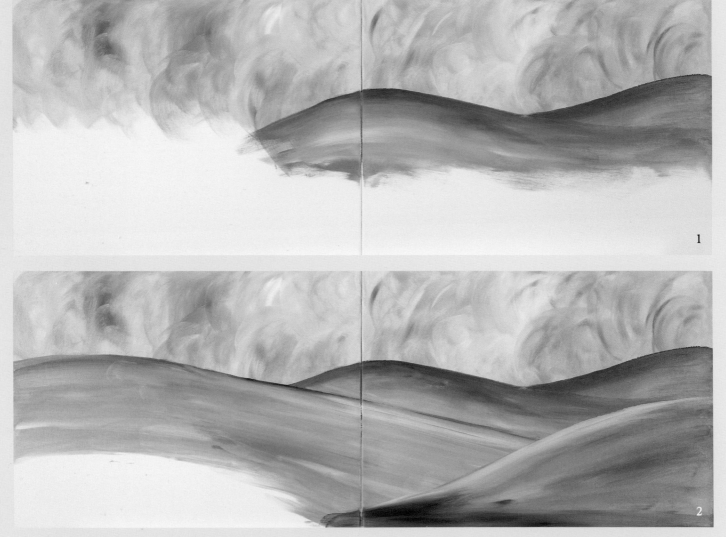

1

2

1 Begin with the sky area. Always load Clear Medium first on your sponge painter when painting large areas like this. Then pick up Brilliant Ultramarine plus Wicker White and use circular motions of the sponge to swirl in the sky colors. Double load a clean sponge with Yellow Ochre and Maple Syrup, pick up Autumn Leaves, and sponge on the shapes of the background hills on the right. Let these hills cross over the center division where the two canvases meet.

2 Double load a sponge painter with Burnt Umber and Sunflower and pick up a little Yellow Ochre plus medium. Stroke in the shapes of the background hills on the left side, letting the hills cross over the center division. Establish the top edge of these hills with Burnt Umber stroked on wet-in-wet over the Sunflower. Come back to the right side and place the foreground hill with the same colors, picking up more Autumn Leaves on your dirty sponge. The shading color at the center bottom edge of the canvas is Berry Wine.

Paint the Focal Point

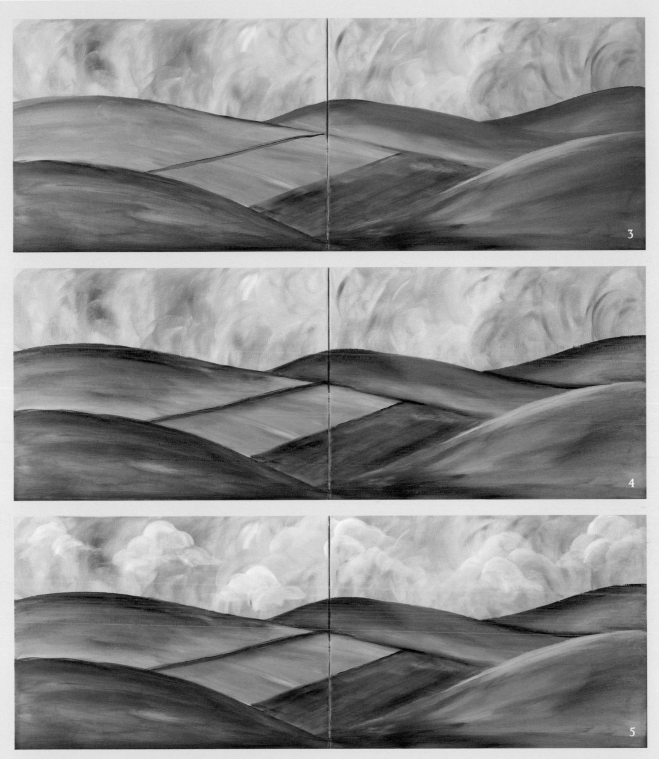

3 The final foreground hill on the left side is sponged on with Yellow Ochre, Berry Wine and Burnt Umber. Double load a 1-inch (25mm) flat brush with Thicket and Sunflower and pick up a little medium. Place in the green field, and draw the pasture line to the left of the green field using the chisel edge of the brush,

follow the contours of the land, and pick up more medium if your brush starts to drag. Strengthen the green line that divides the fields and pull a little of the green into the brown pasture to shade this area.

4 To shade and separate the tops of the hills and indicate the valleys, dress a 1-inch (25mm) flat in Clear Medium, then alternate sideload floats of Burnt Umber, Berry Wine, Autumn Leaves or Thicket. Use long smooth strokes of the brush that

5 Load a sponge painter with Clear Medium and Wicker White and paint puffy white clouds in the sky. The rounded shapes of the cloud tops echo the rounded shapes of the hills below. Use the rounded edge of the sponge painter to draw the clouds, then fill in with thinned Wicker White.

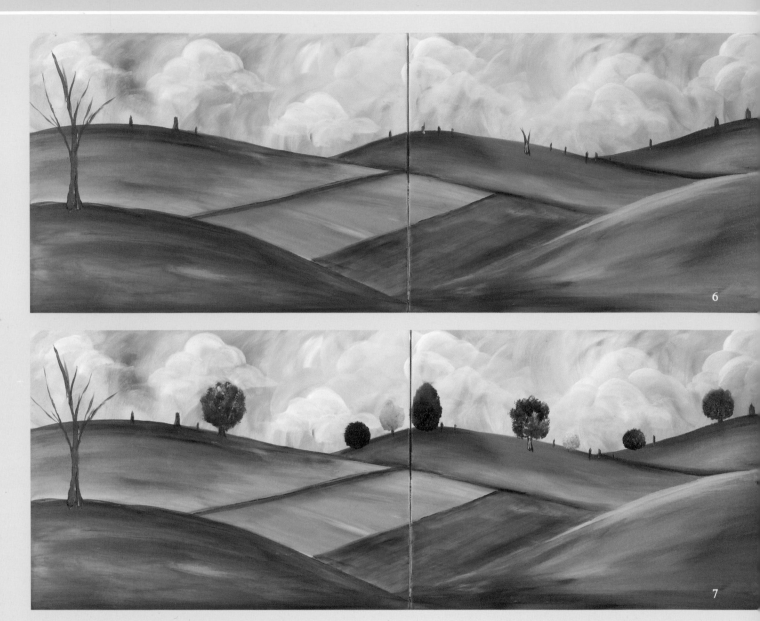

6 Using the chisel edge of a no. 10 flat and Burnt Umber, place in the tree trunks along the background ridges. Be sure to keep the trunks straight up and down even if the hillside is slanted. Use the same brush to draw in the bare trunk and branches of the foreground tree at left.

7 Using a large scruffy, pounce on the foliage of the red and orange trees using Engine Red, Berry Wine, and a tiny bit of Yellow Light. Use these same colors for the round tree at the far right side and the red maple on the distant ridgeline at the left. Pounce on the yellow trees with Yellow Light and Yellow Ochre. Keep these tree shapes very simple and rounded.

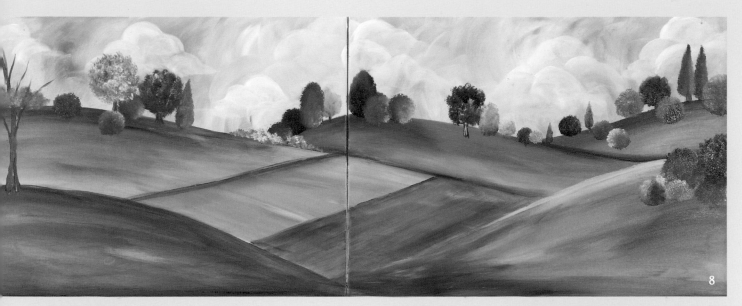

8

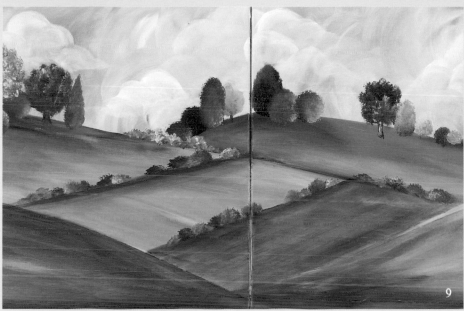

9

10

8 With Thicket or Green Forest and Fresh Foliage double loaded on a scruffy, pounce in all the green tree foliage along the background hills, picking up Yellow Citron sometimes and Yellow Light other times to highlight the foliage. If the tree is too narrow for the scruffy brush, just use the chisel edge of a no. 10 flat to pounce on the colors. Also at this time, pounce on the foreground trees at the right side. The green trees are all shaded on the same side with Thicket pounced on with the corner of the scruffy.

9 Pounce in the low-lying shrubs along the lines separating the fields and pastures using the scruffy or a no. 10 flat. Double load Fresh Foliage and either Thicket or Green Forest, depending on the green you

want, and highlight with either Yellow Citron or Yellow Light. Vary the heights of the shrubs along the dividing lines and leave a gap or opening here and there.

10 Using a no. 4 fan brush with Berry Wine and Engine Red, tap in the foliage of the large red tree in the left foreground. Pick up Burnt Umber on the tips of the bristles to shade the foliage. Keep it light and airy. You should still be able to see the sky and the green background foliage through the leaves.

Paint the Focal Point

11 Using the scruffy, pounce in the shrubs below the foreground red tree with Engine Red and Berry Wine for the red shrub, and Fresh Foliage plus either Thicket or Green Forest for the green shrubs, picking up Yellow Citron sometimes and Yellow Light other times to highlight the foliage.

12 Darken the shading in the bottom foreground area with Berry Wine and Burnt Umber on a 1-inch (25mm) flat dressed with medium. Use the same Berry Wine and medium to enrich the colors of the foreground hill on the left. Stroke in the long narrow leaves of the nearest foreground grasses using the same flat brush. Alternate picking up Forest Moss, Burnt Umber and Yellow Ochre for these grasses, and begin your strokes at the bottom of the canvas and lift to the chisel at the tip end of each blade of grass.

13 Dress a 1-inch (25mm) flat with medium and sideload into Burnt Umber. Shade everywhere under and around the trees and shrubs all along the background hills and in the foreground too. Every once in a while, pick up a little Engine Red to enrich the shading color. Your shading strokes should follow the lay of the land—if the field is sloped, your shading strokes should be sloped too.

14 The buds on the foreground grasses are dabbed on with the chisel edge of a no. 10 flat. Double load Engine Red and Burnt Umber, and pick up Yellow Ochre for some of the buds. Add some small green leaves and stems to the bud stalks using Green Forest.

10 Poppies in the Sierra

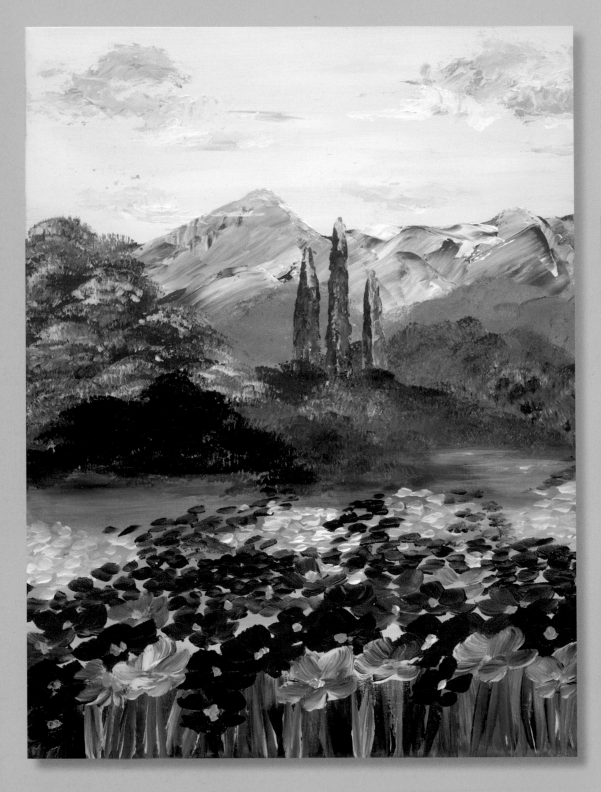

O NE OF MY FAVORITE things to paint is a landscape with large, detailed flowers in the foreground, as if I were nestled in among them and looking out onto a grand scene. The flowers set the stage and lead your eye into the painting, giving the feeling of great distance.

BRUSHES
- no. 4 fan
- 1-inch (25mm) flat
- nos. 10 and 16 flats
- ¾-inch (19mm) flat

CANVASES
Two 18 x 24-inch (.46 x .69m) stretched canvases, with 1½-inch (3.8 cm) thick, staple-free edges, by Fredrix Creative Edge

ADDITIONAL SUPPLIES
- FolkArt Sponge Painters
- FolkArt HD Clear Medium
- Wide palette knife
- Narrow palette knife

FOLKART HIGH DEFINITION ACRYLIC PAINT

Yellow Light

Wicker White

Brilliant Ultramarine

Fresh Foliage

Forest Moss

Burnt Umber

Thicket

Green Forest

Engine Red

Yellow Citron

Periwinkle

Sponge On the Background

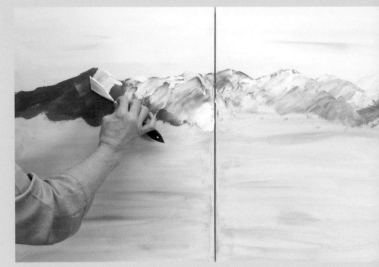

1 Double load Yellow Light and Wicker White on a sponge dressed with Clear Medium and dip into a little Brilliant Ultramarine. Stroke in the sky color using horizontal motions across the canvas. Pick up more yellow sometimes and more blue sometimes to get color variations. Carry this sky color a third of the way down the canvas. Pick up Fresh Foliage and medium on a sponge and block in the green area on the lower two-thirds of the canvas.

2 Pick up Brilliant Ultramarine and Wicker White on a wide palette knife and paint the shapes of the distant mountains. Use diagonal motions with the flat of the knife to achieve the slant of the mountain slopes. Pick up more white on the knife and stroke over the blue slopes to give the appearance of snow.

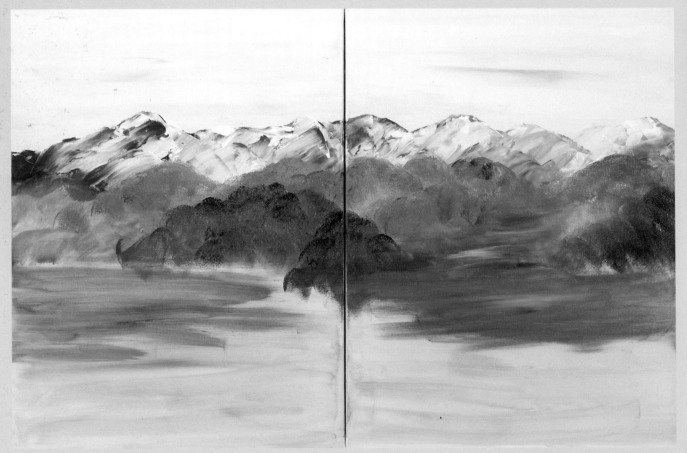

3 Sponge on the midground hills in front of the mountains with Forest Moss and Burnt Umber. If your blue mountains are still wet, use the sponge to tap on the green color so you don't lift the blue and white paint. At the base of the green hills, smooth the paint with the sponge using curving motions to indicate the hills flattening out into the fields. The closer hills are sponged on with Thicket and a little Yellow Light. Blend the greens with lateral motions of the sponge to indicate a pathway in the distance coming into the foreground. Finish the background with areas of Green Forest for the grassy areas of the valley.

Paint the Focal Point

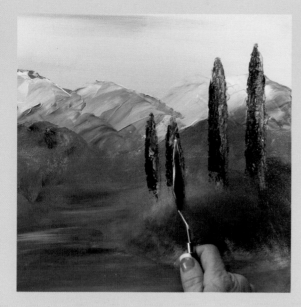

4 With a narrow palette knife, pick up Green Forest and a little Yellow Light and pat in the tall, columnar cedar trees on both sides of the canvas (see the Step 5 photo below for placement of the three cedar trees on the left side). Hold your palette knife vertically and just touch it to the canvas to deposit thick paint. Start at the pointed top of the tree and tap downward widening the tree as you go. While this color is wet, come back with a little more yellow and highlight the sunlit sides of these trees.

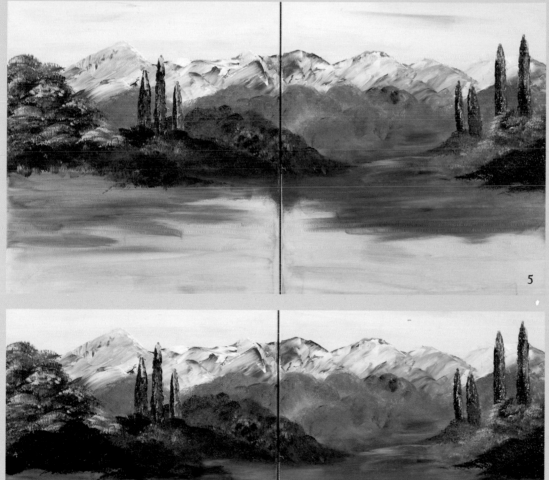

5 Load a no. 4 fan brush with Green Forest and tap in the shrubs on the right side below the cedar trees and the tall deciduous trees on the far left side. Come back with Yellow Light on the fan brush and tap highlights into these areas.

6 Enrich the colors of the shrubs in the midground on both right and left sides of the canvases with Engine Red and Green Forest on a no. 4 fan. Brighten the colors of the fields and valley floor using Yellow Citron and Yellow Light on a sponge. Come back with a little Green Forest to deepen the green color in some areas of the fields. Shade under the red shrubs in the background on the left side with Green Forest as well.

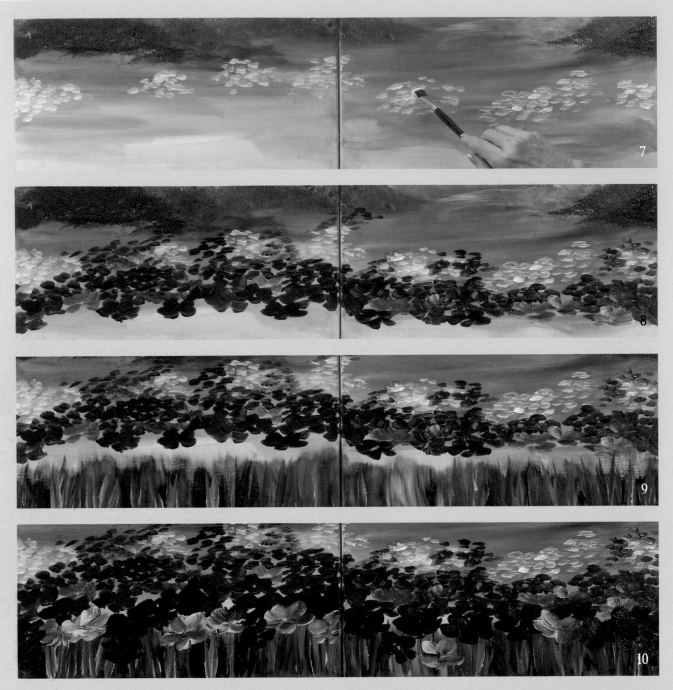

7 Load a no. 16 flat with Yellow Light, occasionally picking up some Wicker White for variety, and tap in clusters of yellow poppies in the midground fields, holding your brush parallel to the horizon so the strokes are wide rather than round.

8 Pick up Engine Red on the dirty brush and tap in clusters of red poppies in the distance. Occasionally pick up yellow with the red to make some orange poppies. As you work your way forward, start picking up a little Burnt Umber as well on your flat brush. As the poppies get closer to the foreground, start painting them with a touch-and-pull stroke because you can start to see the individual petals more clearly.

9 With Green Forest on a 1-inch (25mm) flat, pull a mass of green stalks along the bottom of both canvases all the way across. Stroke upward from the bottom using the flat of your brush. Detail this area with stalks and leaves by picking up Yellow Light on the dirty brush and using the chisel edge to stroke upward. Occasionally pick up some Engine Red for color variation.

10 To paint the details of the poppies in the front row, load a ¾-inch (19mm) flat with Engine Red and pick up some Green Forest to darken the red somewhat. Paint the five petals of each poppy, using a short curved stroke for each petal. For the brighter red poppies, pick up more Engine Red. For the yellow poppies, pick up Yellow Light on the dirty brush. For orange poppies, pick up a little red on your yellow brush.

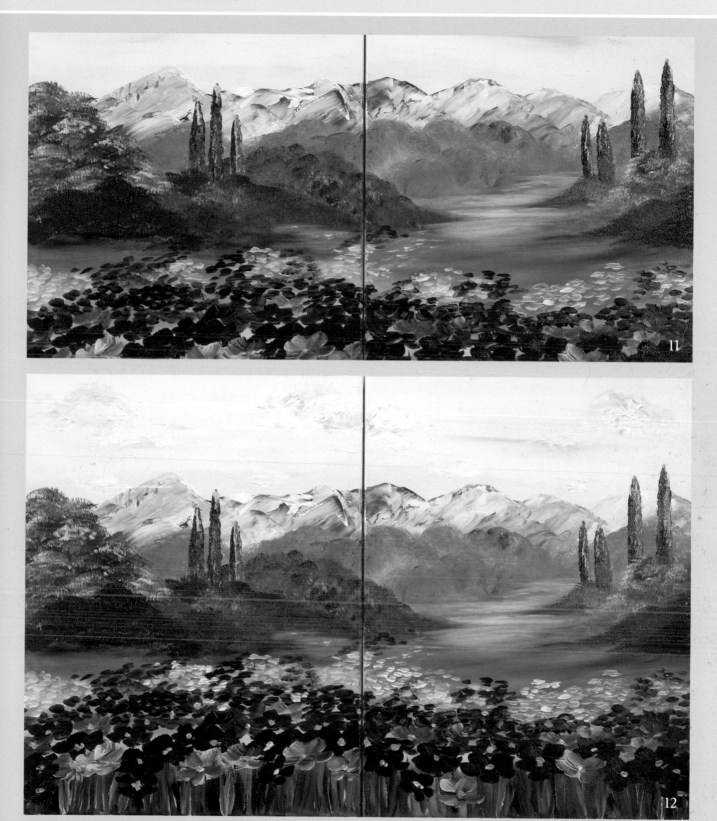

11 Lighten the colors of the valley floor in the background using Yellow Light and Wicker White on a ¾-inch (19mm) flat. Stroke this across the valley using slightly curving horizontal motions, and pull some of the darker greens into it from the foliage areas on the sides.

12 Paint the clouds in the sky using Brilliant Ultramarine and Wicker White on the narrow palette knife. Leave them very thick and textured. With a no. 10 flat, load Periwinkle and Wicker White and dot in the centers of some of the poppy flowers. Don't do this on all the poppies, that would be boring. Just do them here and there for little sparks of contrasting color among all the red.

11 Through the Garden

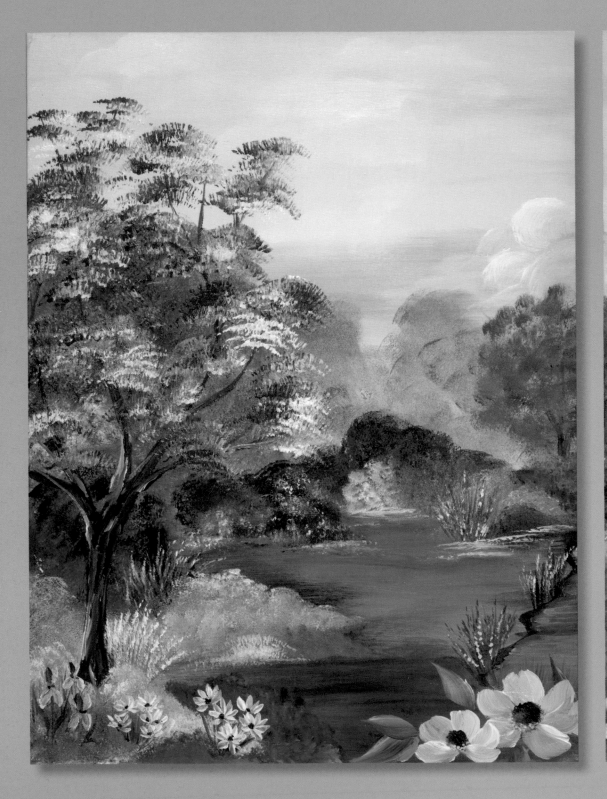

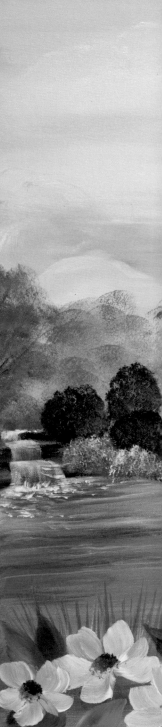

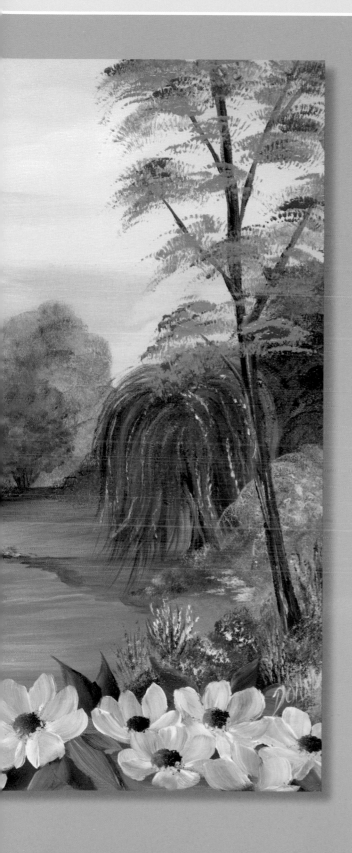

P AINTING LUSH GARDENS like these is not only fun to do, it's fast and easy because I use the scruffy and the fan brush to paint the trees and most of the flowers. This is a springtime scene with lots of pinks and purples which contrast beautifully with the big white cosmos in front.

BRUSHES
- 1-inch (25mm) flat
- nos. 10 and 16 flats
- Large scruffy
- no. 4 fan
- ¾-inch (19mm) flat
- no. 2 script liner

CANVASES
Two 18 x 24-inch (.46 x .69m) stretched canvases, with 1½-inch (3.8 cm) thick, staple-free edges, by Fredrix Creative Edge

ADDITIONAL SUPPLIES
- FolkArt Sponge Painters
- FolkArt HD Clear Medium

FOLKART HIGH DEFINITION ACRYLIC PAINT

Yellow Light Sunflower Wicker White

Magenta Fresh Foliage Thicket

Forest Moss Violet Pansy Green Forest

Periwinkle Burnt Umber Butter Pecan

Lavender Yellow Citron Brilliant Ultramarine

Pure Orange

Sponge On the Background

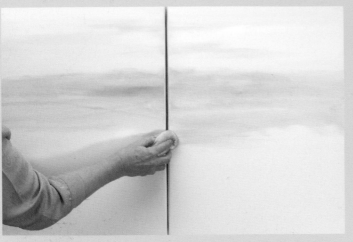

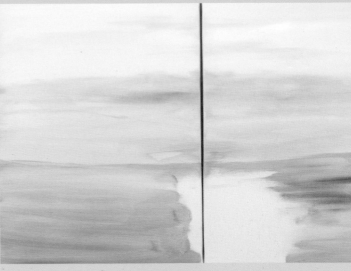

1 On a sponge painter dressed with Clear Medium, load Yellow Light, Sunflower and Wicker White. Stroke in the sky color using horizontal motions across the two canvases. Pick up Magenta sometimes to get color variations. Carry this sky color over the top half of the canvases. Pick up more Yellow Light to brighten the upper sky here and there.

2 Load a medium-dressed sponge painter with Fresh Foliage and pick up a little Thicket. Block in the green grass area across the lower half of the two canvases. Leave a space unpainted for the pond to come.

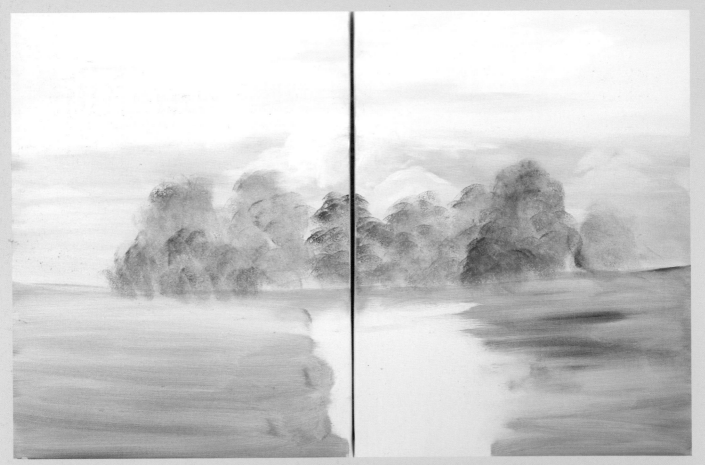

3 Pick up Wicker White on the sponge plus a little Magenta or Sunflower and use the edge of the sponge to draw puffy clouds in the sky. Tap the paint out and pull across it with the flat of the sponge to soften the edges and blend them out. Use a sponge dressed in lots of medium plus Forest Moss to tap in a few of the background trees in the far distance. Use Violet Pansy on the same dirty sponge for the rest of the background trees.

Paint the Focal Point

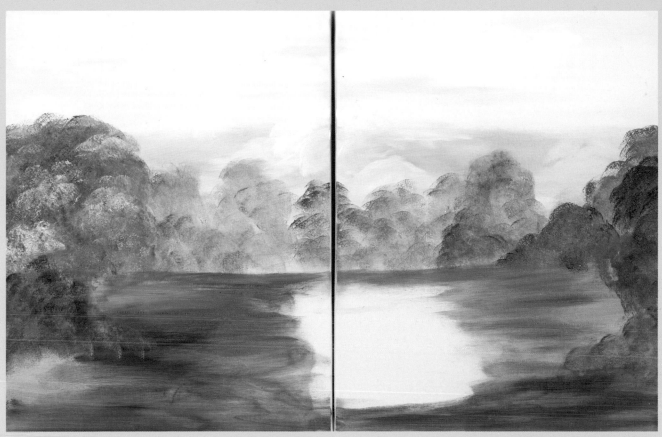

4 Double load Thicket and Fresh Foliage on a sponge and dab in the foliage of the large green trees on the left and right sides of the canvases. Highlight the foliage here and there with Yellow Light on the left-side tree. With the same sponge and colors, use the flat of the sponge to darken the green grassy areas that surround the pond. Tap in a very dark green tree on the right with Green Forest.

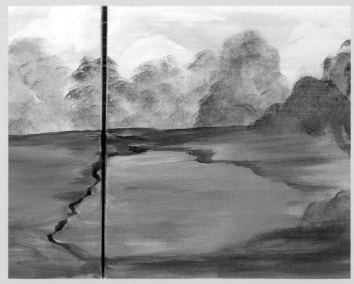

5 Block in the blue water of the pond using Periwinkle on a sponge dressed in medium. With Burnt Umber and Butter Pecan on a 1-inch (25mm) flat, establish the higher ground in the background from which the little waterfalls will drop. Also place in the muddy shoreline around the pond.

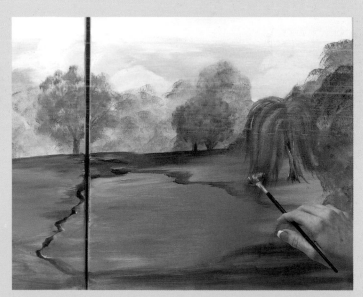

6 For the small flowering trees in the background, draw in the trunks and branches with the same brown using the chisel edge of the no. 16 flat. Pounce on the foliage and flower color at the same time using the scruffy loaded with Fresh Foliage and Lavender. The weeping willow tree at the right is painted with the no. 4 fan brush and Thicket and Green Forest, highlighted with Fresh Foliage and a little Wicker White.

Paint the Focal Point

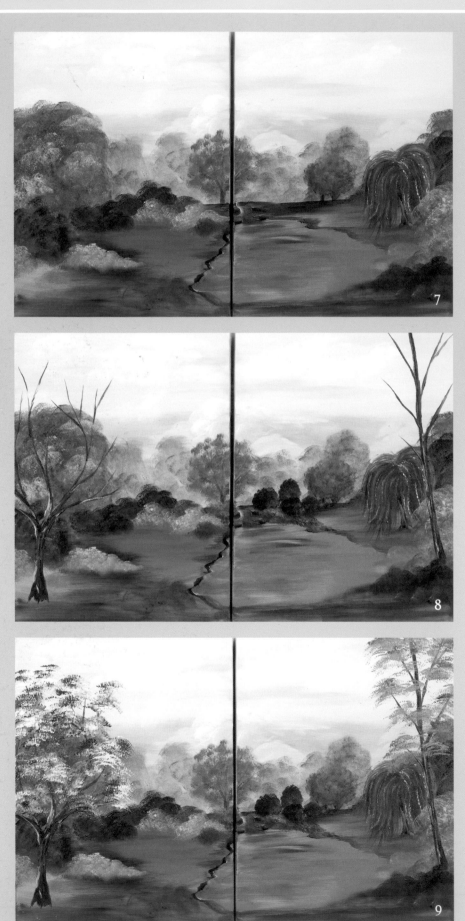

7 Pick up Yellow Citron and Yellow Light on a sponge painter and dab in the flowering shrubs at the far right side in front of the willow tree, and on the left. The dabbing motion leaves good texture on your canvas. Add more green shrubs to the background to the left of the pond and also at the bottom right. These will serve as backgrounds for the colorful flowers to come. Load a no. 16 flat with Brilliant Ultramarine and Wicker White and paint the blue water cascading down the slope in the background.

8 Add more green foliage to the right of the cascades and along the stream banks below the cascades, using the scruffy brush loaded with Thicket and Fresh Foliage. Use the chisel edge of a 1-inch (25mm) flat and Burnt Umber to draw in the trunks and branches of the very tall trees on either side of the painting. Highlight with Wicker White. Leave the paint thick to indicate rough bark.

9 The foliage of the large flowering tree on the right is tapped on with a no. 4 fan brush and Yellow Citron and Fresh Foliage. Tap on the flowers with Lavender. The pink flowering tree on the left is Magenta and Wicker White tapped on with the no. 4 fan brush.

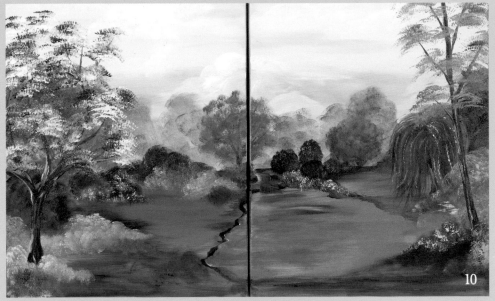

10 Pounce in a few red flowers on the trees behind the cascades using Magenta on the scruffy brush. Tap in a tiny bit of Wicker White to highlight. Use the same brush and colors to add the small mounds of pink flowers at the left and right sides below the two tall trees. Pounce on dark purple flowers using Lavender and Brilliant Ultramarine double loaded on the scruffy. Highlight with a few light taps of Wicker White. Also highlight the low row of bushes along the pond shoreline.

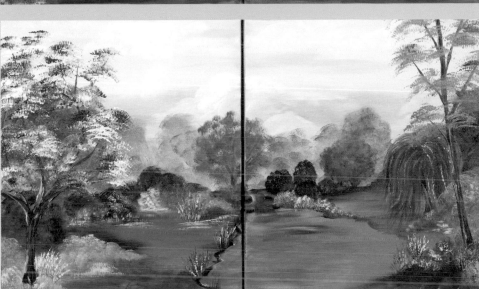

11 Load a no. 10 flat with Green Forest and use the chisel edge to pull spiky leaves in the background and along the shoreline. Add flowers to the spiky leaves in the background with Lavender and Wicker White, then Yellow Light and just a tiny bit of Pure Orange. Tap in the white flowers throughout with Wicker White using the tips of the fan brush.

12 With a no. 16 flat and Wicker White, indicate the whitewater flowing over the falls and the foamy water at the bottom. Keep the white thin and translucent so the blue still can be seen.

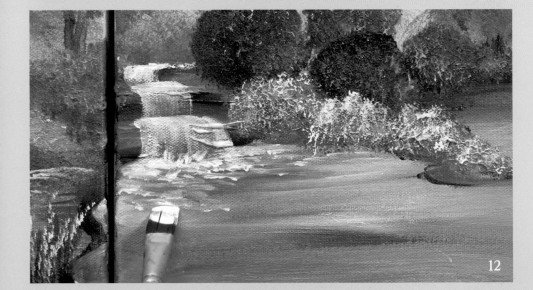

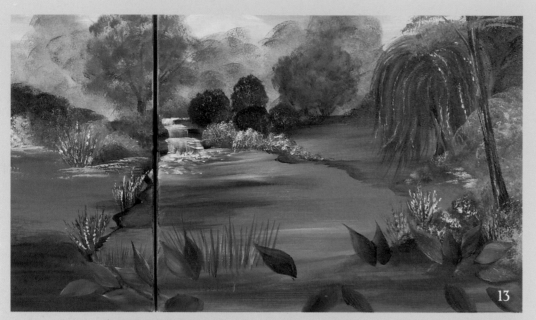

13 Load a 1-inch (25mm) flat with medium and Green Forest and indicate the shadow being cast over the water by the trees on the left. With the same brush, pick up some Yellow Citron and use the chisel edge to pull thin leaves vertically at the foreground shoreline of the pond. Pick up Thicket on the dirty brush and paint the large one-stroke leaves that are in the extreme foreground along the bottom of the canvases.

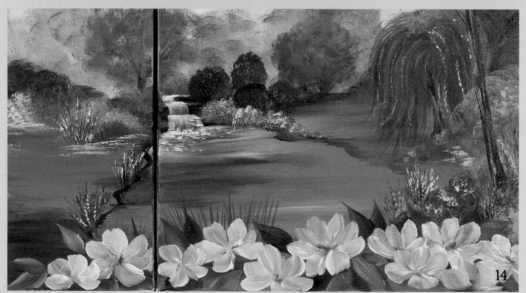

14 To begin the large white cosmos flowers in the foreground, use a ¾-inch (19mm) flat. Load it with Thicket on one flat side, flip the brush over and pick up Wicker White on the other flat side. Paint each petal with the white side of the brush (the green will come through enough to tint the white a little bit). Use a short curving stroke for the more cupped petals, and a touch and pull stroke for the straight petals. Let one or two blossoms extend off the bottom edge of the canvas and don't forget to take them around the sides and bottoms of the canvases.

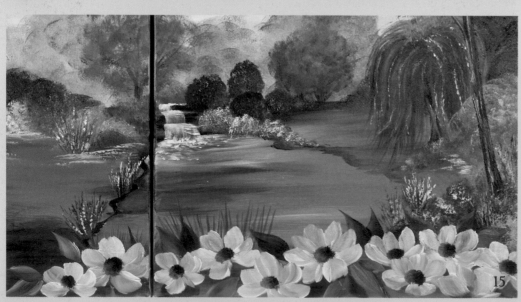

15 Add the centers to the large white cosmos using Burnt Umber and Yellow Citron pounced on with the scruffy brush.

Fill In with the Details

16 Highlight the cosmos centers with Sunflower and a little Yellow Light using the no. 2 script liner and tapping on dots of color along one side.

17 The tiny yellow and white flower clusters in the foreground at the far left are painted with little chisel-edge strokes using a no. 10 flat, double loaded with Yellow Light and Wicker White for the yellow flowers and Sunflower and Wicker White for the white flowers. Their stems are Green Forest and their centers are Burnt Umber.

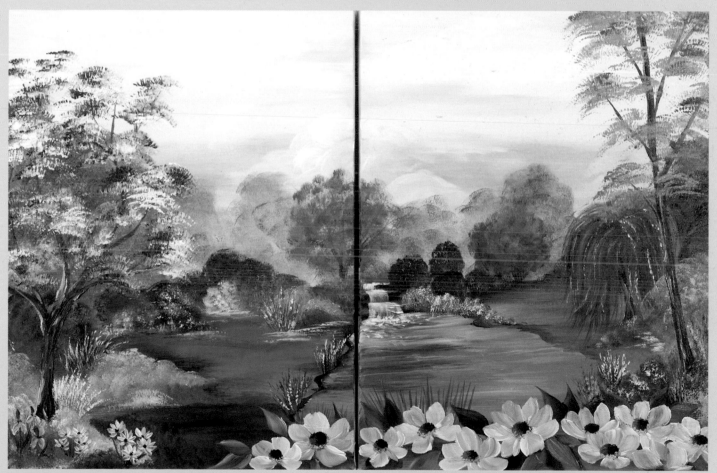

18 The final details in the water are painted with the no. 10 flat loaded with Periwinkle and Wicker White. Use the chisel edge and short back-and-forth horizontal strokes to indicate water movement. Keep a light touch on your brush for this. Finally, shade under and around the flowering shrubs using a 1-inch (25mm) flat dressed in medium and sideloaded into Burnt Umber.

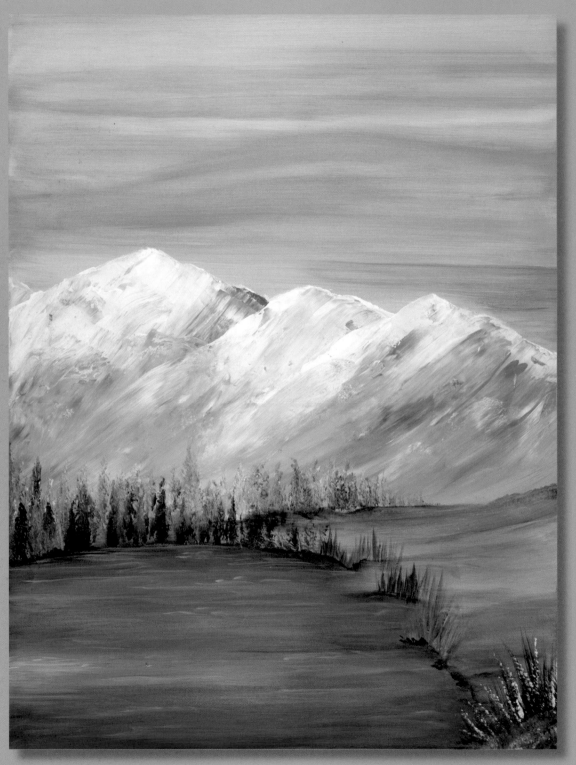

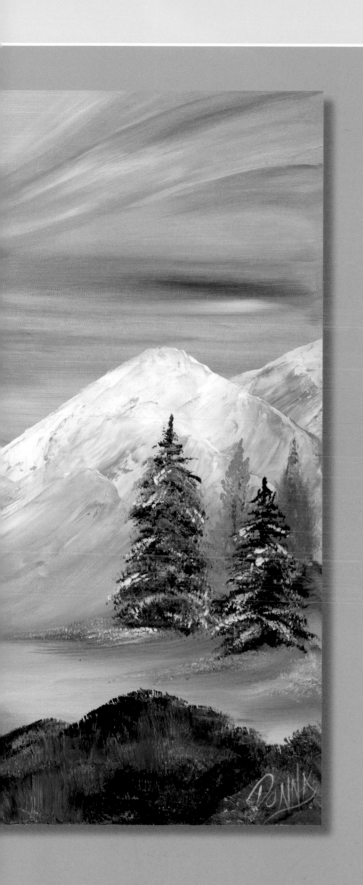

A WIDE PALETTE KNIFE was the only tool I used to paint these snow-covered mountains. By double loading the knife with white and a warm or cool blue, I created the color variations and all the rocky textures in the slopes and ridges. Then I used a sponge to smooth out the valleys.

BRUSHES
- no. 4 fan
- 1-inch (25mm) flat
- no. 10 flat

CANVASES
Two 18 x 24-inch (.46 x .69m) stretched canvases, with 1½-inch (3.8 cm) thick, staple-free edges, by Fredrix Creative Edge

ADDITIONAL SUPPLIES
- FolkArt Sponge Painters
- FolkArt HD Clear Medium
- Wide palette knife
- Narrow palette knife

FOLKART HIGH DEFINITION ACRYLIC PAINT

 Cayman Blue

 Magenta

 Brilliant Ultramarine

 Yellow Light

 Yellow Citron

 Wicker White

Fresh Foliage

Thicket

Green Forest

Sponge On the Background

1 Using a sponge painter, pick up Clear Medium and Cayman Blue and start at the top of the canvases. Block in the sky color using horizontal strokes across both canvases. For the other sky colors, pick up Magenta for the pinks, and Brilliant Ultramarine for the deeper blue. For the sunrise colors in the center, pick up Yellow Light on the sponge. Work wet-into-wet with all these colors and keep picking up medium to keep your colors thin and transparent. Block in the green color of the valley with Yellow Citron on a sponge painter dressed with medium.

2 Block in the pond area at the lower left using Cayman Blue, Brilliant Ultramarine and Wicker White.

3 Sponge on the wavy cirrus clouds using the same colors on the sponge, but pick up more Wicker White. Stroke across the sky area starting at the upper right corner of the canvas and curving gently downward.

Paint the Focal Point

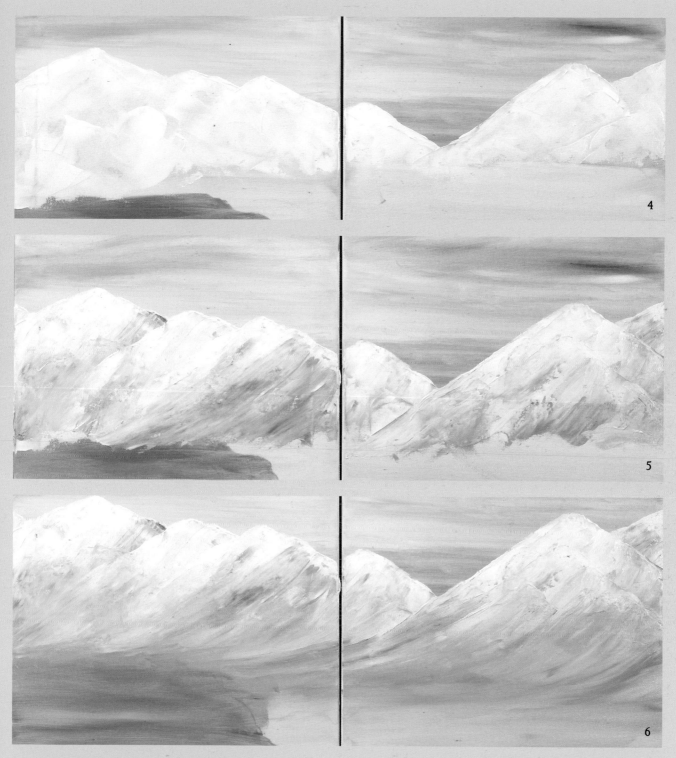

4 With a wide palette knife, pick up Wicker White and block in the shapes of the mountains, using the edge of the knife to draw the shapes and the flat of the knife to fill in.

5 Pick up Cayman Blue on your wide knife and work wet into wet to shade and shape the slopes of the mountains and to provide background color for the white snow. Keep the blue below the very top ridgelines of the mountains where the snow is the whitest. If you get blue too close to the tops, just come back in with more

Wicker White on your knife and re-establish the white in these areas. To shade the valleys and help separate the mountains from one another, pick up some Brilliant Ultramarine on the knife.

6 Pick up medium on your sponge and a little Brilliant Ultramarine and smooth out the lower slopes of the mountains where they flatten out and meet the green valley. Then pick up Fresh Foliage on the sponge plus more medium, and soften and blend the greens of the valley floor.

Paint the Focal Point

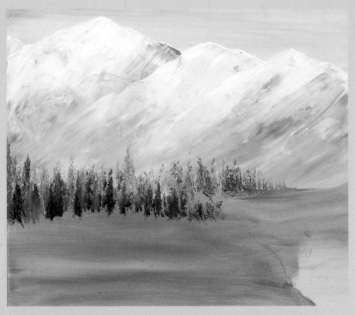

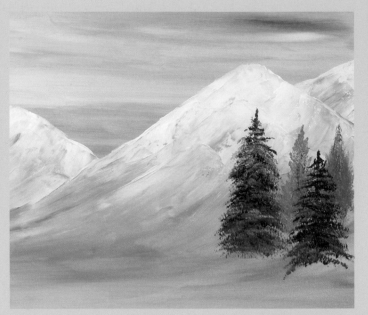

7 On a no. 4 fan brush, lightly load Thicket and Wicker White. Pick up a little Fresh Foliage and tap in the back row of tall evergreen trees on the distant shore of the pond. The evergreens in front have more Thicket on the brush, and some have Green Forest. Use the chisel edge of the fan brush to lightly tap in these trees.

8 The larger, closer evergreens on the right side are placed in with the same colors. The two lighter background trees have more white in the mix and are more solid. The darker trees in front have more Green Forest on the brush and are tapped on more sparingly. The dusting of snow on the branches will be done later.

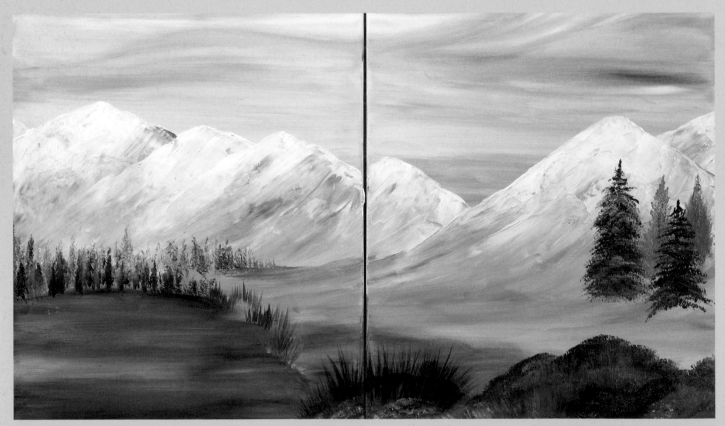

9 Using a 1-inch (25mm) flat, pick up medium, Magenta and Brilliant Ultramarine and start working these colors into the pond water. Use lateral strokes only. Keep the blue along the shoreline and pull in to the center from there. At the back shoreline, add some thinned Green Forest for reflections of the evergreens. With a no. 10 flat double loaded with Thicket, Fresh Foliage and a little Wicker White, use the chisel edge to pull the tall spiky leaves of the reeds along the shore. Load the no. 4 fan brush with Green Forest and Fresh Foliage and tap on the foreground shrubs in the lower right and center. Use the very tips of the fan brush to pull thin stalks up out of the foliage in the center.

Fill In with the Details

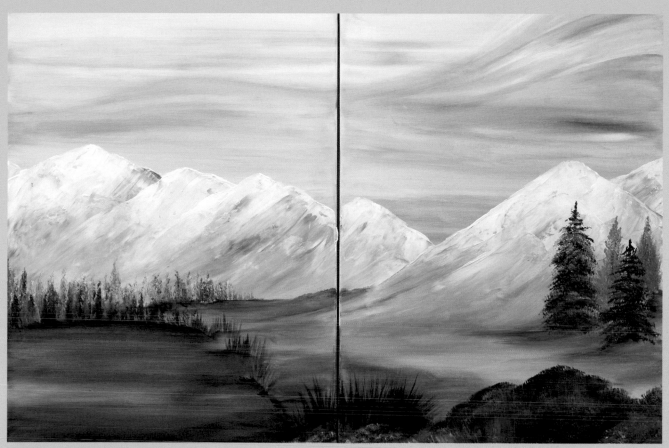

10 With the 1-inch (25mm) flat, dress the brush with medium and sideload into Green Forest. Shade the grassy field area under the large evergreens, using slightly curving motions of the brush. Shade in the green field area behind the pond and in the valley going up the pass between the mountains, and around the shoreline of the pond.

11 Load a no. 4 fan brush with Wicker White and tap on a dusting of snow on the upright stalks in the center, under the large evergreens at the right, and on a few of the branches. Don't overdo the snow; let the green show through.

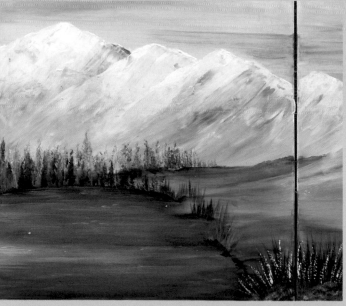

12 Using a 1-inch (25mm) flat, highlight the pond water with a little more of the pink reflection from the sky colors, using the chisel edge and short horizontal strokes. Pick up more white on the tip of the brush to indicate waves, water movement and reflections of the snow-covered mountains.

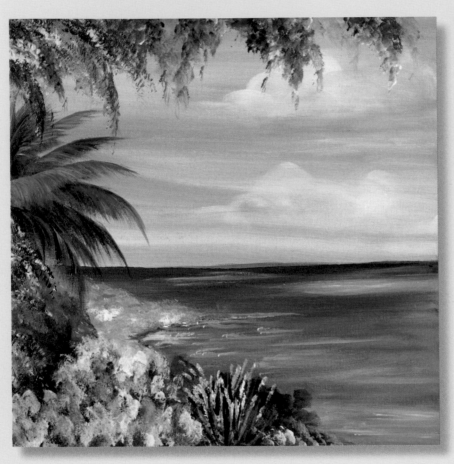

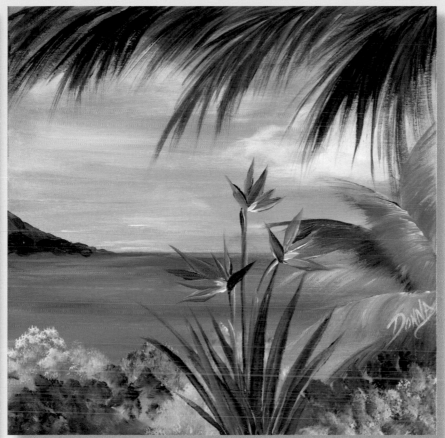

P ANORAMIC SCENES

like this are absolutely breathtaking when painted horizontally across a set of three square canvases! The extreme width gives you the feeling of a never-ending sky and a vast ocean view.

BRUSHES
- ¾-inch (19mm) flat
- no. 4 fan
- 1-inch (25mm) flat
- Large scruffy
- nos. 10 and 16 flats

CANVASES
Three 16-inch (.41m) square stretched canvases, with 1½-inch (3.8 cm) thick, staple-free edges, by Fredrix Creative Edge

ADDITIONAL SUPPLIES
- FolkArt Sponge Painters
- FolkArt HD Clear Medium
- Wide palette knife

(See paint colors on next page.)

Place In the Background

FOLKART HIGH DEFINITION ACRYLIC PAINT

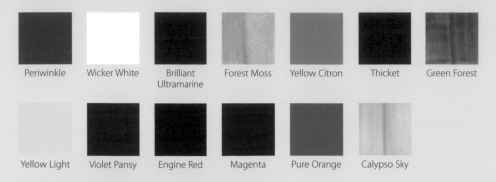

Periwinkle	Wicker White	Brilliant Ultramarine	Forest Moss	Yellow Citron	Thicket	Green Forest
Yellow Light	Violet Pansy	Engine Red	Magenta	Pure Orange	Calypso Sky	

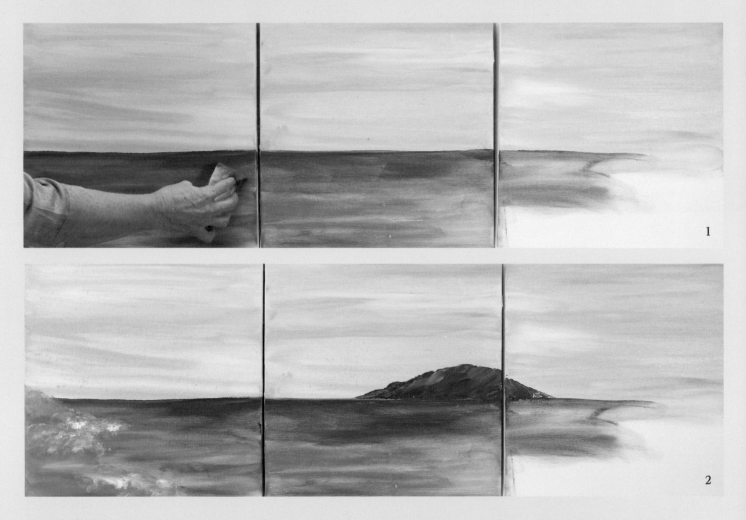

1

2

1 Begin with the sky area, and always pick up Clear Medium on your sponge painter first when painting large areas like this that cross over all three canvases. Using horizontal motions of the sponge and Periwinkle plus Wicker White, stroke in the sky colors. For the open ocean, pick up Brilliant Ultramarine on your dirty sponge and use long horizontal strokes that cross the two left canvases and extend over to the right one.

2 Using a wide palette knife, pick up thick Brilliant Ultramarine and place the island off in the distance. Use the edge of the knife to shape the ridgeline. Fill in with the flat of the knife using diagonal strokes that begin at the ridgeline and angle downward to the base. Add green to the island's slopes with Forest Moss on the knife. With Forest Moss and Yellow Citron on a sponge painter, dab on foliage on the far left side of the leftmost canvas.

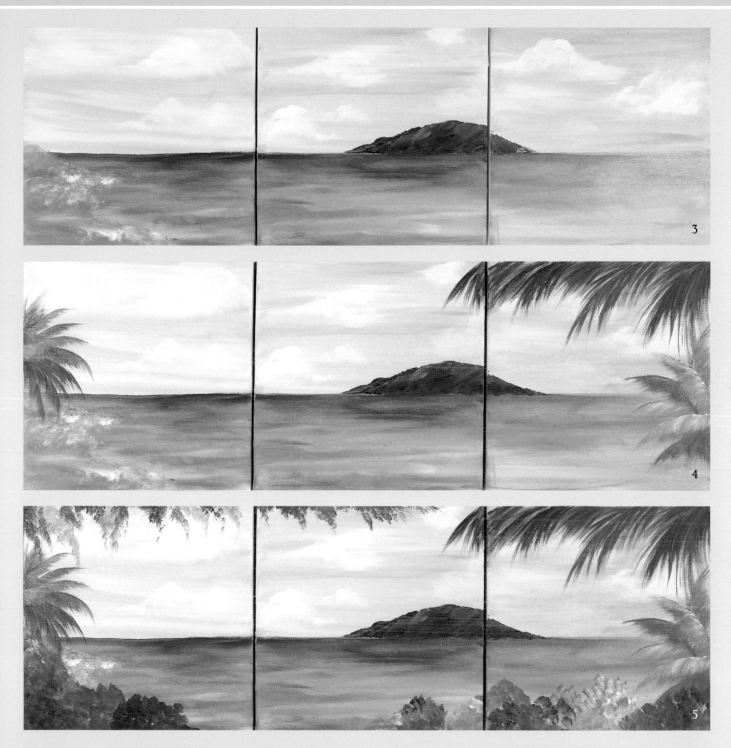

3 Draw in the white clouds with Wicker White using the curved edge of a sponge painter. Use the flat of the sponge to sweep lightly across the clouds to soften their edges.

4 Paint the large overhanging palm fronds in the upper right using a ¾-inch (19mm) flat double loaded with Thicket and Green Forest. Pick up Yellow Citron occasionally for warmer color. Stay up on the chisel edge as you stroke each curving palm frond. To get a more feathered and airy look to some of the leaves, use the same colors on a no. 4 fan brush and lightly stroke some very thin curving lines. Use the same brushes and colors for the palm at the far left side. On this one,

paint a curving line for the center stem of the frond, then pull the leaves downward using the chisel edge of the brush. Pick up Yellow Light to highlight these palms. The palm at the far right side is painted with Yellow Citron, Wicker White and a little Thicket to shade, using the no. 4 fan brush.

5 With a 1-inch (25mm) flat brush, dab on all the greenery around the canvas. This green provides the background for all the bright flower colors to come. Alternate picking up Green Forest, Thicket, Yellow Citron, Wicker White and Yellow Light on your brush to achieve all the different shades of green shown here.

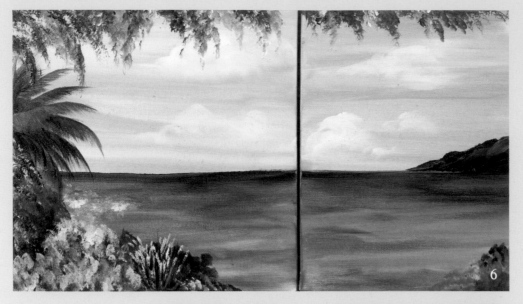

6 Double load the scruffy brush with Violet Pansy and Wicker White, and pick up a little Brilliant Ultramarine. Pounce on the wisteria blossoms hanging down along the upper left of the canvases. Double load a no. 4 fan brush with Engine Red and Yellow Light and dab on the red and yellow honeysuckle flowers on the far left side. Use the chisel edge of the 1-inch (25mm) flat and Wicker White for some white stalk flowers at the lower left side. Load the scruffy with Yellow Light and Wicker White and pounce on the bright yellow flowers at the bottom left. Finish by re-stating some of the green in this area.

7 For the pink flowers along the center bottom, use a no. 4 fan brush loaded with Magenta and Wicker White. The smaller pink flowering shrub is pounced on with the scruffy. Pick up just Wicker White on the scruffy for the white flowering shrub, then pick up Brilliant Ultramarine for the blue flowers at the bottom right corner.

8 To begin the large bird-of-paradise plant at the right side, draw the spiky leaves with the chisel edge of a no. 16 flat using Green Forest and some Yellow Light. Begin the pointed flower petals with the no. 10 flat double loaded with Pure Orange and a little Wicker White. The purple petals are Violet Pansy and a little Wicker White.

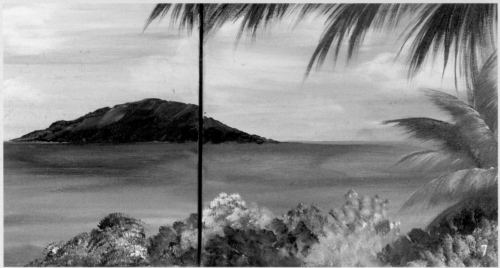

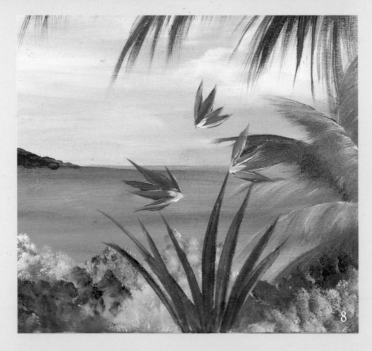

Fill In with the Details

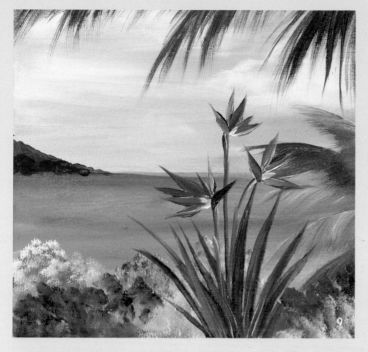

9 Draw the stems of the flowers downward using the chisel edge of the no. 10 flat and Green Forest plus Yellow Light. Using the dirty brush, pick up a little Engine Red and paint the pointed red petals on the bird-of-paradise blossom.

10 Using the 1-inch (25mm) flat, work some tropical colors into the ocean water. Dress the brush with lots of medium, then pick up Magenta, plus a little Brilliant Ultramarine and Wicker White. Use short, lateral, chisel-edge strokes to indicate moving water and to show some of the colors reflected from the clouds and the sky. Pick up some Calypso Sky on the same brush and paint the shallow water close to the foreground shore. Pick up more white on the brush and streak in the waves that are closer to the shore as well.

11 Add some color to the sky and along the edges of the clouds using a little Yellow Light on a 1-inch (25mm) flat dressed with lots of medium. For the pinkish color, pick up a little Magenta and Wicker White. Use back-and-forth horizontal motions to apply these subtle colors and don't overdo it to keep the illusion of great distance.

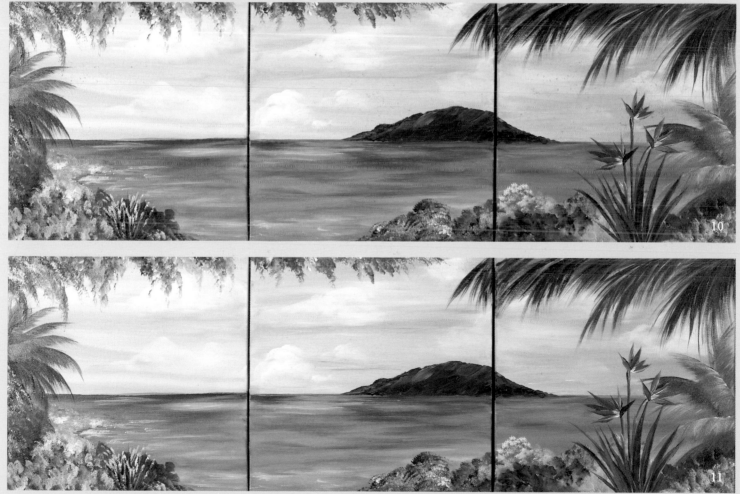

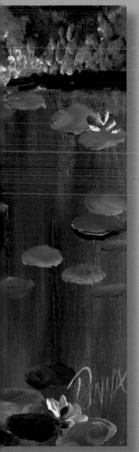

14 Water Lilies

PAINTING REFLECTIVE WATER that has some depth and movement is a bit different from painting reflections in still water. Where there is movement in the water, the colors of the trees and flowers on the shoreline are reflected using vertical strokes of a sponge, but the shapes are only suggested.

BRUSHES
- 1-inch (25mm) flat
- no. 4 fan
- ¾-inch (19mm) flat
- no. 10 flat

CANVASES
Four 14-inch (36 cm) square stretched canvases, with 1½-inch (3.8 cm) thick, staple-free edges, by Fredrix Creative Edge

ADDITIONAL SUPPLIES
- FolkArt Sponge Painters
- FolkArt HD Clear Medium
- Wide palette knife
- Narrow palette knife

FOLKART HIGH DEFINITION ACRYLIC PAINT

Periwinkle

Wicker White

Green Forest

Thicket

Forest Moss

Magenta

Fresh Foliage

Brilliant Ultramarine

Yellow Ochre

Yellow Light

Sponge On the Background

1 Double load Periwinkle and Wicker White on a sponge painter dressed with Clear Medium. Stroke in the sky color using horizontal motions across the top two canvases. Carry this color around the top and side edges of the canvases.

2 On the bottom two canvases, use the same colors but make vertical strokes with the sponge to block in the water area. Then pick up more medium and some Green Forest and begin stroking in the green color in the water using vertical strokes of the sponge.

3 Finish the green water area, picking up Thicket sometimes for the darker areas and Wicker White sometimes for the lighter areas and reflections. Keep your strokes vertical for the water area. This is what gives the look of reflections in moving water as opposed to the glassy "mirror-image" reflections you would see in still water.

Paint the Focal Point

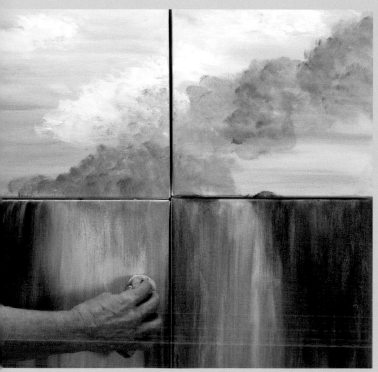

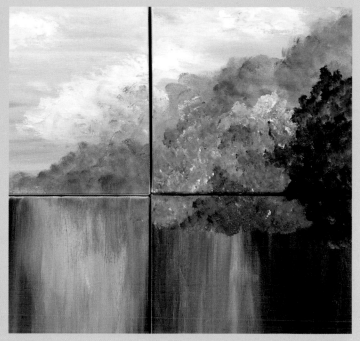

4 Using a wide palette knife and Wicker White, place in the white clouds using thick paint. Leave the clouds textured, don't smooth them down. The background shadow trees are dabbed on with a sponge dressed with medium, using Forest Moss and Green Forest for some, and picking up a little Periwinkle for others. Pick up some Magenta and medium on the dirty sponge and dab on some very subtle pink color into the trees in the center. Drag this color down into the water area using vertical strokes of the sponge to create reflections.

5 With a 1-inch (25mm) flat loaded with Green Forest and Periwinkle, picking up a little Fresh Foliage sometimes, dab in the foliage of the large green tree on the right. Highlight with Wicker White and shade with Green Forest. For the shorter trees in front, use the dirty brush and pick up Forest Moss, Wicker White and Magenta.

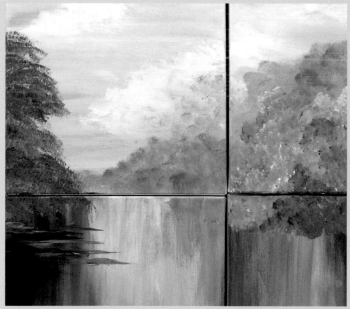

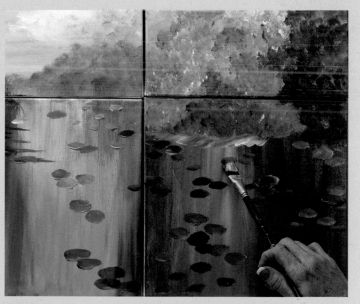

6 At the far left side, use a no. 4 fan brush and Thicket and Fresh Foliage to tap in the foliage of the tall tree. Load a 1-inch (25mm) flat with Green Forest and Fresh Foliage and use the chisel edge to indicate water movement at the left side.

7 Use a ¾-inch (19mm) flat double loaded with Fresh Foliage and Wicker White to paint the lighter lily pads in the water area. Pick up Green Forest sometimes for darker green pads. Lily pads are round but because they are laying flat on the water, due to perspective they will have an oval or elliptical shape in the painting.

125

Paint the Focal Point

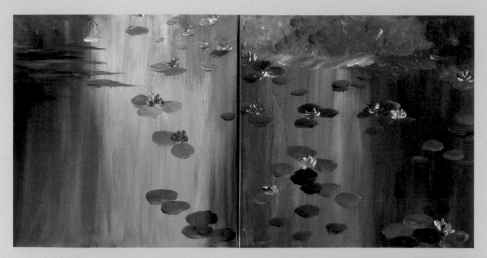

8 The water lily flowers are stroked in with a no. 10 flat double loaded with Magenta and Wicker White. Keep the paint very thick for these flowers as you want them to stand up from the canvas surface.

9 The row of flowers along the shoreline on the right side is painted with the no. 10 flat. The colors are Brilliant Ultramarine, Magenta, Yellow Ochre, each highlighted with Wicker White.

10 With Green Forest and Periwinkle on a 1-inch (25mm) flat, pull a mass of spiky green iris leaves up from the bottom left corner. Pick up Fresh Foliage sometimes to highlight, and Magenta once in a while for color variation and to echo the color of the pink iris blossoms.

11 To paint the details of the foreground irises, load a ¾-inch (19mm) flat with Magenta and Wicker White. Stroke three upper petals (the "standards") and two lower petals (the "falls") for each iris blossom. Pick up more Magenta sometimes and more white other times for color variations in the petals. Paint a couple of buds with one or two strokes.

Fill In with the Details

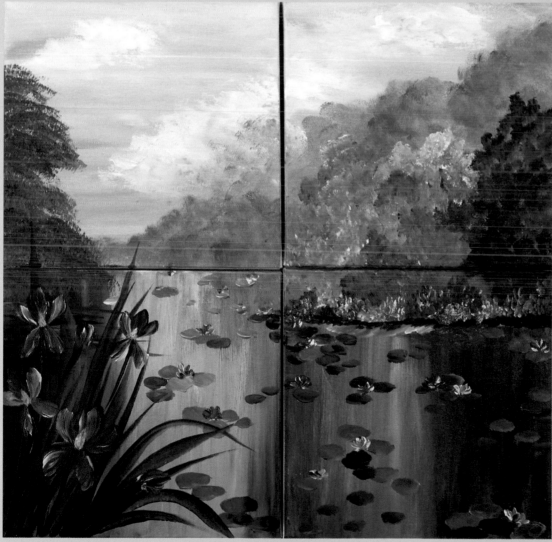

12 Establish the shoreline under the row of flowers with Green Forest on a ¾-inch (19mm) flat.

13 Paint the yellow beards in the centers of the irises with Yellow Light. Stroke the ¾-inch (19mm) flat through Green Forest and touch into Magenta, and paint the stems of the irises with long vertical strokes.

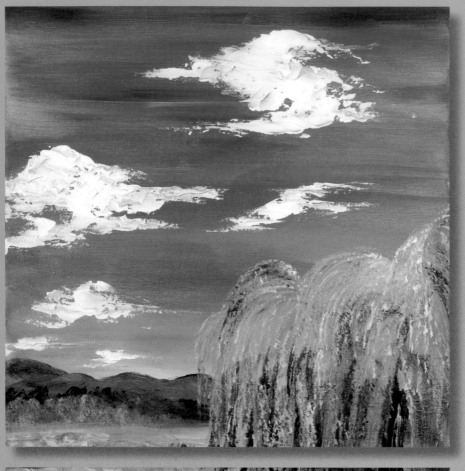

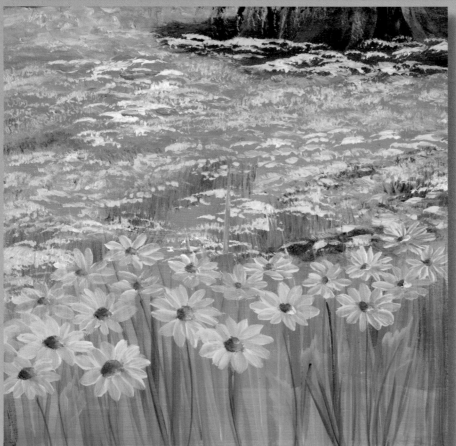
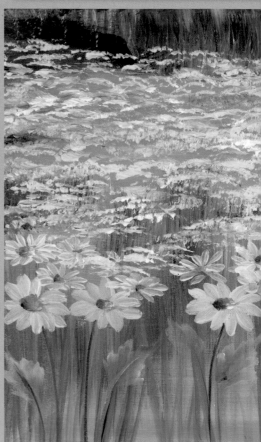

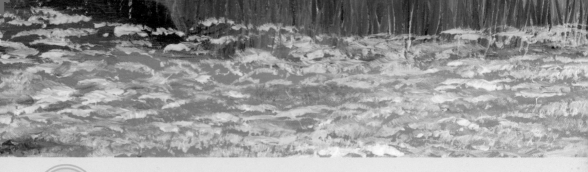

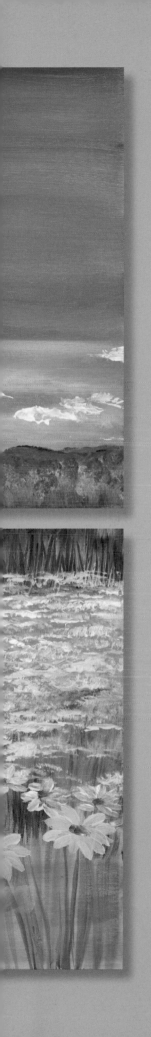

15 Fields of Daisies

HERE'S ANOTHER EXAMPLE of a landscape I painted on four square canvases that are arranged into a larger square. It's almost like I'm looking through a window at this lovely scene. The bright spring colors and clear blue sky are fresh and inviting, and yellow daisies are such fun to paint!

BRUSHES
- no. 4 fan
- nos. 10 and 16 flats
- 1-inch (25mm) flat

CANVASES
Four 16-inch (.11m) square stretched canvases, with 1½-inch (3.8 cm) thick, staple-free edges, by Fredrix Creative Edge

ADDITIONAL SUPPLIES
- FolkArt Sponge Painters
- FolkArt HD Clear Medium
- Wide palette knife

FOLKART HIGH DEFINITION ACRYLIC PAINT

Brilliant Ultramarine Wicker White Calypso Sky

Fresh Foliage Thicket Yellow Citron

Yellow Light Burnt Umber Periwinkle

Sponge On the Background

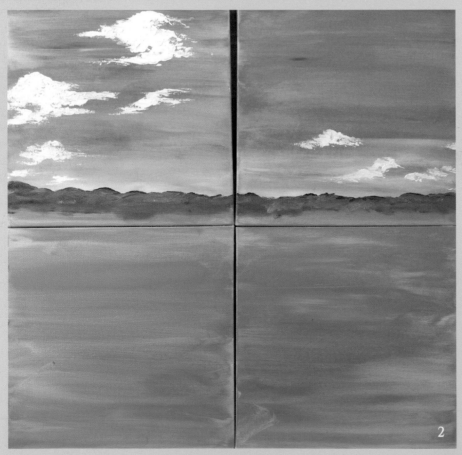

1 Double load Brilliant Ultramarine and Wicker White on a sponge dressed with Clear Base medium. Pick up some Calypso Sky on the sponge and stroke in the sky color using horizontal motions across the top two canvases. Carry this color around the top and side edges of the canvases. Pick up more Calypso Sky and deepen the sky color along the top and left sides. If the lower sky area along the horizon line is too dark, wipe off some of the blue. Dress a clean sponge painter in Clear Medium and block in the green field with Fresh Foliage using long horizontal strokes across both lower canvases. Extend this green color up into the bottom of the upper two canvases. Don't forget to carry this color around the top, bottom, and side edges of the lower two canvases.

2 Using a wide palette knife and Wicker White, place in the white clouds using thick paint. Leave the clouds textured, don't smooth them down. The dark background trees along the horizon line are dabbed on with a sponge dressed with medium, using Fresh Foliage and Brilliant Ultramarine to get a bluish green.

Paint the Focal Point

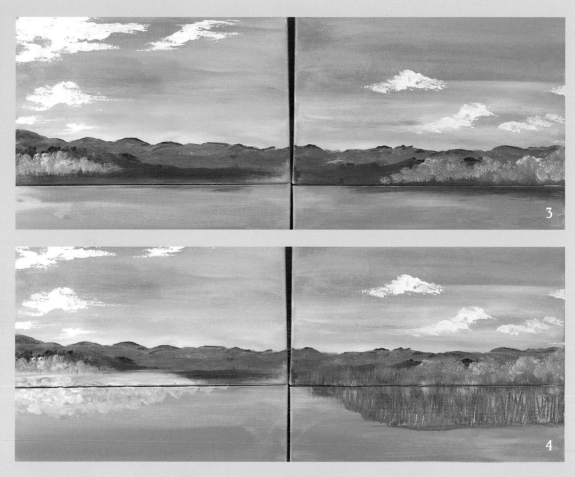

3 Pick up Thicket on a sponge painter dressed with medium and darken the green field area in front of the background trees. With Fresh Foliage and Wicker White on a scruffy, add the lighter green shrubbery on either side of the background trees.

4 Use a no. 4 fan brush and Thicket, Yellow Citron and Yellow Light to stroke in the tall grasses on the right with upward strokes. While this is wet, pick up Yellow Citron on a no. 16 flat and use the chisel edge to stroke individual stalks of tall grass. With Yellow Light and Wicker White on a no. 10 flat, dab on the light yellow foliage at the left side.

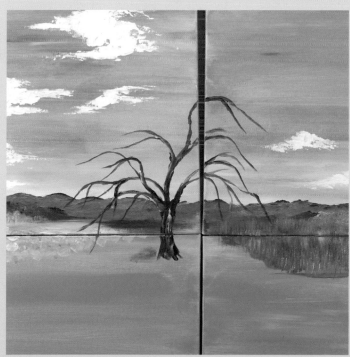

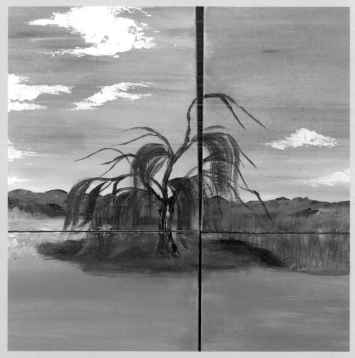

5 Double load a no. 16 flat with Burnt Umber and Wicker White and draw in the shapes of the willow tree's trunk and branches. This is an asymmetric tree so let the branches have irregular shapes and lengths for more interest.

6 Load a no. 4 fan brush with Thicket and pick up medium. Dab on the darker, shaded foliage of the willow tree, then use a downward stroking motion to indicate the darker hanging branches.

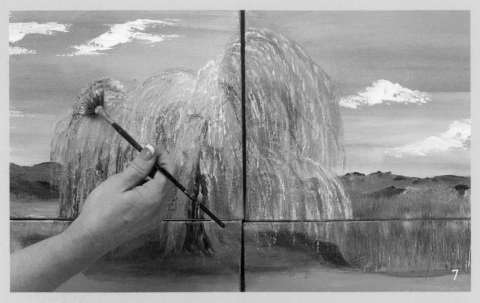

7 Using the same dirty brush, pick up Yellow Citron and begin painting the lighter green willow branches, again using curving downward strokes. The lightest individual leaves are lightly tapped on with just the very tips of the fan brush bristles. Re-establish the darker, shaded areas if needed with Thicket on the same brush.

8 Double load the no. 4 fan brush with Yellow Light and Wicker White and begin tapping on tiny spots of yellow for the drifts of daisies in the far field in front of the willow tree, working your way forward into the foreground. Every once in a while, pick up some Yellow Citron to indicate the green leaves and stems of the daisies. Pick up more white sometimes to indicate white daisies in among the yellow ones. Also pick up Thicket sometimes for shadows. To begin the foreground daisies, load Thicket and Brilliant Ultramarine on a fan brush and pick up medium. Use light vertical strokes to suggest clusters of stems. Pick up Yellow Light and Wicker White on the tips of the fan brush bristles and tap in the daisy blossoms on the tops of these stems.

9 Using a 1-inch (25mm) flat dressed with medium, alternate picking up a little Thicket, a little Periwinkle, and a little Yellow Citron and use the chisel edge to paint the tall stems of the closest daisies in the foreground. To paint the petals of the closest daisies, double load a no. 10 flat with Yellow Light and Wicker White and paint little chisel edge strokes for the petals. As you work your way forward, use a larger flat brush to paint larger petals. For interest and a more natural look, paint some of the daisies facing upward and some facing forward. Overlap the blossoms here and there. Add some wiggle edge leaves using the same greens used for the background foliage. Dab in the daisy centers with Periwinkle and Wicker White.

Fill In with the Details

10 So they don't compete so much with the willow tree, knock back the yellows in the background tree line by dabbing on a little Thicket for better contrast. Tie in the blues of the sky by dabbing in Periwinkle in among the background daisies.

11 Shade the centers of some of the foreground daisies with tiny dabs of Brilliant Ultramarine, again tying in the sky colors with the foreground colors to make a cohesive painting, which is especially important when you're working on multiple canvases.

Resources

Index

The best in art instruction is from NORTH LIGHT BOOKS!

Donna Dewberry's Painted Garden
Beautify your outdoor decor with Donna Dewberry! See how easy it is to transform ordinary outdoor furniture and accessories into unique decorative objects using Donna's popular One-Stroke painting technique. With hundreds of colorful step-by-step photos, you'll learn how to paint 37 all-new projects, from wooden planters and glass candleholders to metal windchimes, an outdoor clock and so much more. The paints are durable and weatherproof and the projects are fun to do, even for complete beginners! ISBN-13: 978-1-58180-949-7, ISBN-10: 1-58180-949-2, paperback, 128 pages, #Z0658

Sponge Painting: Fast & fun techniques for creating beautiful art
Want to paint gorgeous florals and dramatic landscapes on canvas in less than three hours? Professional artist Terrence Tse shows you how to put all the joy back into painting with his fun and unique sponge-painting techniques. His secret? He uses regular acrylic paints and a common household sponge! In this full-color, step-by-step book, you can choose from 20 start-to-finish painting demonstrations and create your own masterpiece in as little as 90 minutes. You'll learn how to use a sponge to paint everything from orchids, lilies and tulips to palm trees, bamboo and cherry blossoms; from moonlit lakes and reflective rivers to poppy-strewn fields, misty mountains and an early morning sunrise. No brushes—and no experience—needed! ISBN-13: 978-1-58180-962-6, ISBN-10: 1-58180-962-X, paperback, 128 pages, #Z0686

Painting Landscapes Filled with Light
Capture the rich, illusive properties of light! In 10 step-by-step projects, beloved artist Dorothy Dent shares her easy-to-master techniques for painting light-filled landscapes in different seasons, weather conditions and times of day. Projects include oil and acrylic painting demos, with advice for adapting the technique used for one medium to that of the other. Prepare to be amazed by the landscapes you create! ISBN-13: 978-1-58180-736-3, ISBN-10: 1-58180-736-8, paperback, 144 pages, #33412

Painter's Quick Reference: Landscapes
When you're in a hurry for landscape painting help, here's the book to turn to for ideas, instruction and inspiration. With more than 40 step-by-step demonstrations by 26 artists, *Painter's Quick Reference: Landscapes* shows you how to paint all the major landscape elements, including clouds, mountains, trees, water and much more. Use this special guide to jumpstart your creativity, learn painting techniques or explore new mediums—including acrylics, watercolor and oils. ISBN-13: 978-1-58180-814-8, ISBN-10: 1-58180-814-3, paperback, 128 pages, #33495

These books and other fine North Light titles are available at your local arts & crafts retailers, bookstores, or from online suppliers.

Color Recipe Cards

HAVE YOU EVER made a trip to the art or craft supply store to buy paints for the projects you want to do, then forgotten which colors you need? Here's the answer to that problem!

On this and the next four pages are photos of all the landscape paintings in this book. On the back of each photo is a "Color Recipe Card" showing all the colors you will need to paint each landscape. These cards are already perforated so you can easily tear out the ones you need and take them with you to the store. Look for FolkArt HD (High Definition) Visual Texture acrylic paint, made by Plaid. If you cannot find this brand of paint, the color swatches on the cards will help you match the colors I used to other acrylic paints as closely as possible.

When you are finished with your card, just file it in your painting area or store it inside this book. Now shopping for new paint colors is quick and convenient!

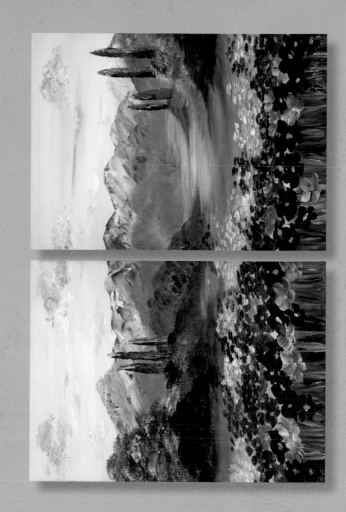

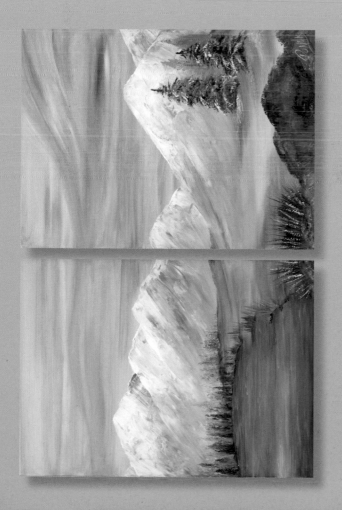

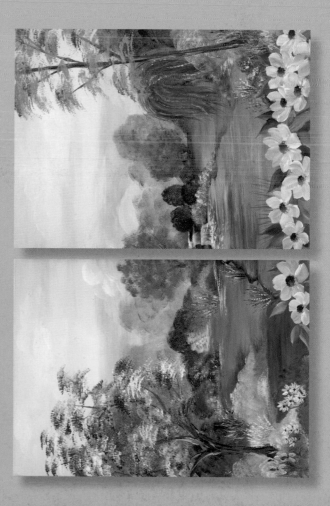

Poppies in the Sierra

FOLKART HIGH DEFINITION ACRYLIC PAINT

Yellow Light	Wicker White	Brilliant Ultramarine	Fresh Foliage	Forest Moss
Burnt Umber	Thicket	Green Forest	Engine Red	Yellow Citron
Periwinkle				

Through the Garden

FOLKART HIGH DEFINITION ACRYLIC PAINT

Yellow Light	Sunflower	Wicker White	Magenta	Fresh Foliage
Thicket	Forest Moss	Violet Pansy	Green Forest	Periwinkle
Burnt Umber	Butter Pecan	Lavender	Yellow Citron	Brilliant Ultramarine
Pure Orange				

Winter Snows

FOLKART HIGH DEFINITION ACRYLIC PAINT

Cayman Blue	Magenta	Brilliant Ultramarine	Yellow Light	Yellow Citron
Wicker White	Fresh Foliage	Thicket	Green Forest	

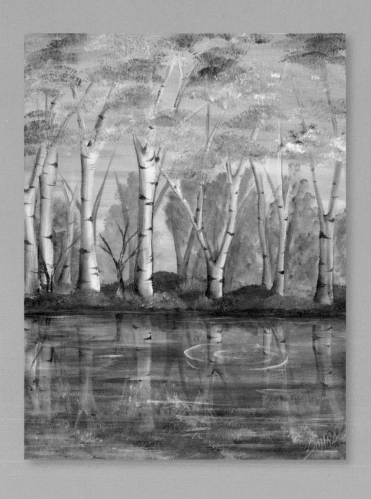

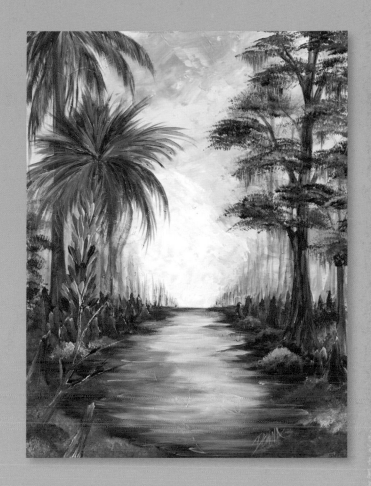

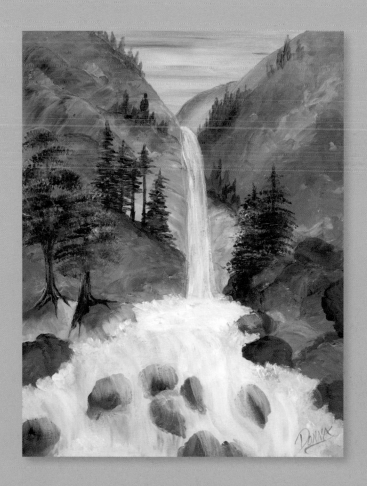

Sunrise in the Everglades

FOLKART HIGH DEFINITION ACRYLIC PAINT

| Sunflower | Yellow Ochre | Yellow Light | Wicker White | Burnt Umber |

| Thicket | Green Forest | Yellow Citron | Brilliant Ultramarine | Licorice |

Birch Tree Reflections

FOLKART HIGH DEFINITION ACRYLIC PAINT

| Periwinkle | Wicker White | Yellow Citron | Thicket | Brilliant Ultramarine |

| Burnt Umber | Yellow Ochre | Yellow Light |

Golden Reflections

FOLKART HIGH DEFINITION ACRYLIC PAINT

| Yellow Ochre | Maple Syrup | Engine Red | Sunflower | Wicker White |

| Burnt Umber | Thicket | Berry Wine | Night Sky | Green Forest |

Yellowstone Falls

FOLKART HIGH DEFINITION ACRYLIC PAINT

| Brilliant Ultramarine | Wicker White | Butter Pecan | Maple Syrup | Yellow Ochre |

| Pure Orange | Sunflower | Burnt Umber | Green Forest | Yellow Citron |

Postcard from Hawaii

FOLKART HIGH DEFINITION ACRYLIC PAINT

Periwinkle	Wicker White	Brilliant Ultramarine	Forest Moss	Yellow Citron
Thicket	Green Forest	Yellow Light	Violet Pansy	Engine Red
Magenta	Pure Orange	Calypso Sky		

Harvest Hills

FOLKART HIGH DEFINITION ACRYLIC PAINT

Brilliant Ultramarine	Wicker White	Yellow Ochre	Maple Syrup	Autumn Leaves
Burnt Umber	Sunflower	Berry Wine	Thicket	Engine Red
Yellow Light	Green Forest	Fresh Foliage	Yellow Citron	Forest Moss

Fields of Daisies

FOLKART HIGH DEFINITION ACRYLIC PAINT

Brilliant Ultramarine	Wicker White	Calypso Sky	Fresh Foliage	Thicket
Yellow Citron	Yellow Light	Burnt Umber	Periwinkle	

Water Lilies

FOLKART HIGH DEFINITION ACRYLIC PAINT

Periwinkle	Wicker White	Green Forest	Thicket	Forest Moss
Magenta	Fresh Foliage	Brilliant Ultramarine	Yellow Ochre	Yellow Light